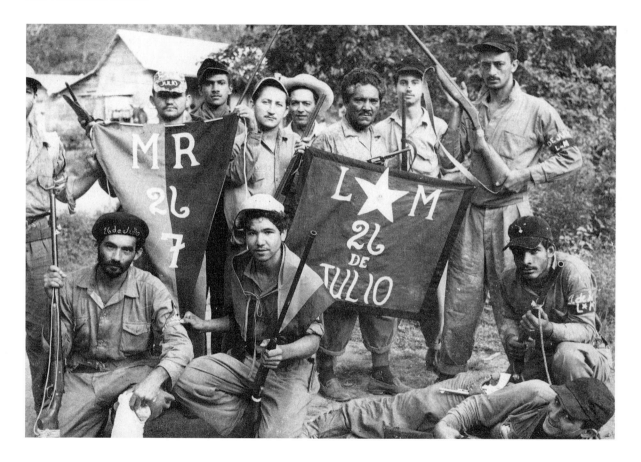

Florida A&M University, Tallahassee
Florida Atlantic University, Boca Raton
Florida Gulf Coast University, Ft. Myers
Florida International University, Miami
Florida State University, Tallahassee
University of Central Florida, Orlando
University of Florida, Gainesville
University of North Florida, Jacksonville
University of South Florida, Tampa
University of West Florida, Pensacola

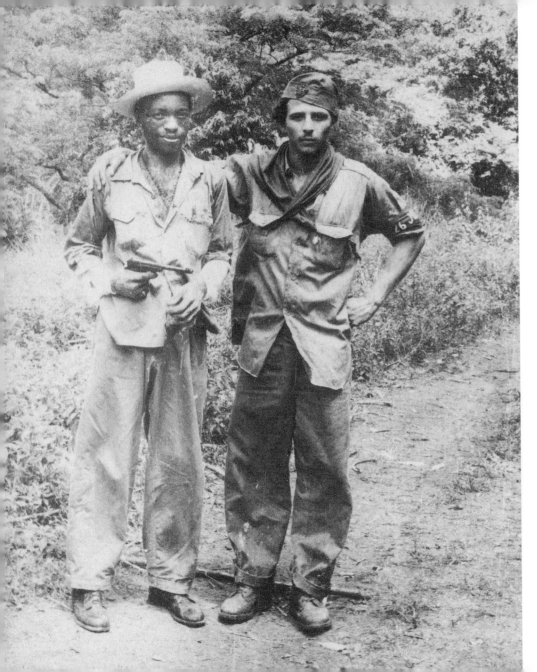

University Press of Florida

GAINESVILLE · TALLAHASSEE · TAMPA · BOCA RATON

PENSACOLA · ORLANDO · MIAMI · JACKSONVILLE · FT. MYERS

The Cuban Revolution

Years of Promise

Teo A. Babún and Victor Andrés Triay

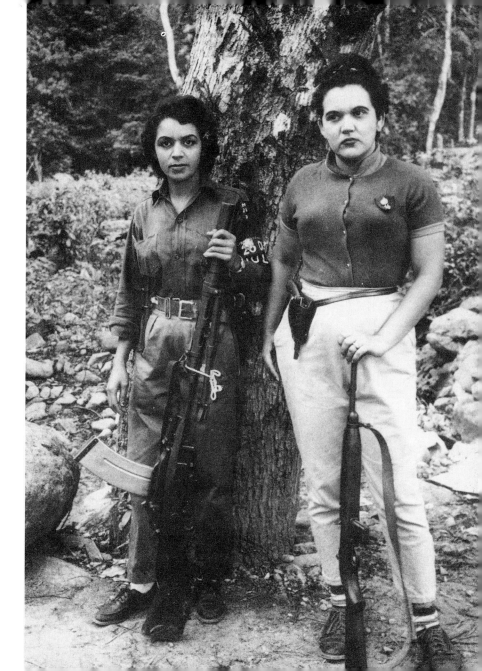

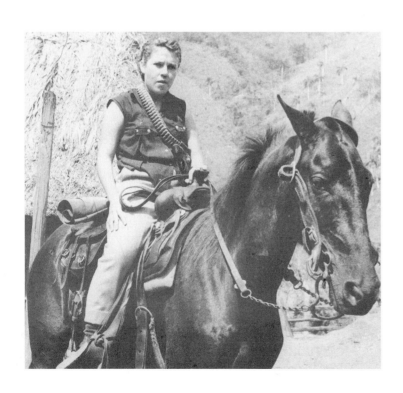

10 09 08 07 06 05 6 5 4 3 2 1

Babún, Teo A.
The Cuban Revolution: years of promise / Teo A. Babún and Victor Andrés Triay.
p. cm.
ISBN 0-8130-2860-4 (alk. paper)
1. Cuba–History–1933–1959–Pictorial works. 2. Cuba–History–Revolution,
1959–Pictorial works. 3. Cuba–History–1959–Pictorial works. 4. Cuba–History–
1933–1959. 5. Cuba–History–1959–. I. Triay, Victor Andrés, 1966–. II. Title.
F1787.5.B23 2005
972.9106'3–dc22 2005048560

The University Press of Florida is the scholarly publishing agency for the State
University System of Florida, comprising Florida A&M University, Florida Atlantic
University, Florida Gulf Coast University, Florida International University, Florida
State University, University of Central Florida, University of Florida, University of
North Florida, University of South Florida, and University of West Florida.

University Press of Florida
15 Northwest 15th Street
Gainesville, FL 32611-2079
http://www.upf.com

To my father, Teofilo, "Tofi," who always dreamed of living in a democratic and sovereign Cuba

T.A.B.

For my grandmother, Elena Carrión de Solana, and to my parents, Andrés and María Elena

V.A.T.

Cuba is an independent and sovereign State organized as a unitary and democratic Republic for the enjoyment of political freedom, social justice, individual and collective welfare, and human solidarity.

TITLE I, ARTICLE I, 1940 CUBAN CONSTITUTION

Contents

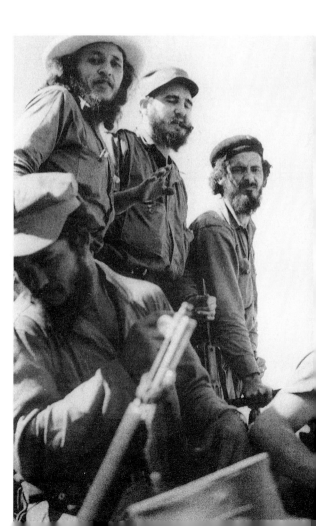

On May 28, 1957, almost six months after his landing in southeastern Cuba, Fidel Castro led his small guerrilla band in an attack against a Cuban army garrison situated within the compound of my father's sawmill of El Uvero, near the town of the same name. The tiny battle of El Uvero, the first significant victory for Castro's guerrillas over the forces of dictator Fulgencio Batista, came on the heels of failed uprisings against the government and helped energize the movement to reestablish democracy in Cuba.

My father, Teofilo "Tofi" Babún, an influential industrialist from nearby Santiago de Cuba, sensed that the events of May 28 marked the beginning of an important period in Cuba's history. He developed a close rapport with the Castro rebels and used his business as a cover to smuggle arms, ammunition, and radio equipment to them. In return, his photographer, José "Chilin" Trutie, was granted special access to the rebels and permission to snap pictures of what he saw. Little did my father know that a few years later a son, three nephews, and a brother-in-law would be landing at the Bay of Pigs in an attempt to overthrow Castro—once again, in the name of Cuban democracy.

Following my father's death in 1987, I found two shoe boxes filled with photographs he had collected of this period, including many of those taken by Trutie. After years of organizing the photographs and identifying faces, I decided to tell the story of the Cuban Revolution and its immediate aftermath through my father's collection. In 2003, I joined forces with Cuban-American historian Victor Andrés Triay to bring this book to fruition. I am sure my father, who died before he could return to a free Cuba, would have been tremendously pleased with the outcome.

Teo A. Babún Jr.
Miami, Florida

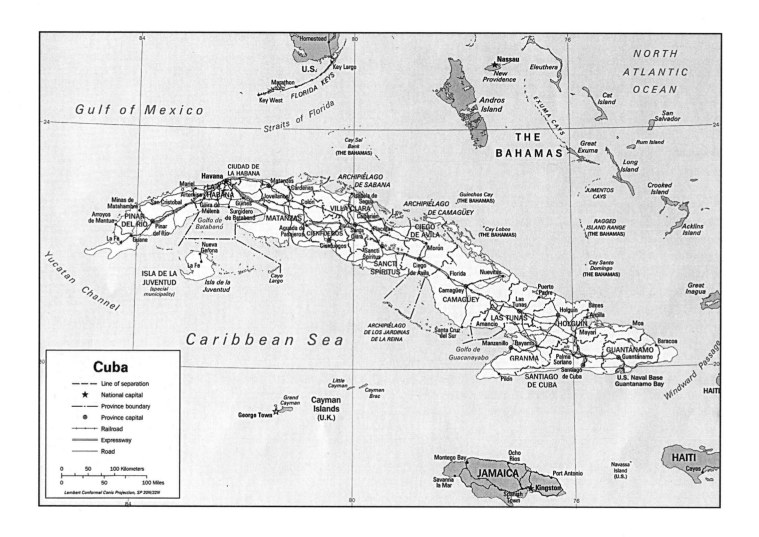

A Photographic History of the Cuban Revolution

This is a photographic history of some of the people and events of the Cuban Revolution and its immediate aftermath. The book captures the adventure, hope, and disappointment of this momentous period in world history.

In 1952 the people of Cuba, furious over a decade of political gangsterism and public corruption, prepared for a national election. Less than three months before election day, however, Fulgencio Batista, a career military man and former president who was running a distant third in the presidential contest, launched a bloodless coup d'état with the support of army officers. He installed himself as president, vowed to end corruption in Cuban politics, and promised to hold elections as soon as possible under the guidelines of Cuba's popular 1940 Constitution, one of the most progressive in Latin America.

Among the candidates for the House of Representatives in the aborted 1952 election was Fidel Castro Ruz. Born in Cuba's easternmost province of Oriente to a Spanish immigrant father who had prospered on the island, Castro was educated in Catholic preparatory schools in Santiago de Cuba (Oriente's capital) and Havana. He entered the University of Havana in 1945 and became associated with the Unión Insurreccional Revolucionaria, one of the university's most notorious gangster political groups.[1] As a student, Castro was considered power hungry and unprincipled, and never achieved high office in university politics.[2] He was, nevertheless, linked to a number of assassinations and other sensational acts of political violence, including a failed invasion of the Dominican Republic in 1947 and the 1948 Bogotazo riots in Bogotá, Colombia, which claimed the lives of three thousand people.[3]

By the time Castro finished law school he was a member of Eduardo Chibás's Ortodoxo Party. Chibás, who before his 1951 suicide brought the crusade against corruption in Cuba to a fever pitch, reportedly considered Castro to be an untrustworthy gangster despite the latter's party activism.[4] In any event, Batista's 1952 coup ended Castro's career as an elected politician even before it started and opened the door for him to take an approach better suited to his personality.

On July 26, 1953, Castro and a group of followers entered Santiago de Cuba and launched a quixotic attack against the Cuban army's Moncada barracks and

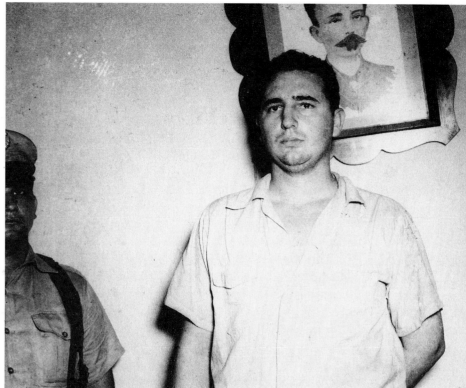

A young Fidel Castro Ruz awaiting trial for his 1953 attack on the Moncada military barracks.

Crowd in front of the west entrance of the Moncada barracks after a failed attempt by Fidel Castro to incite a popular uprising on July 26, 1953.

other nearby targets. A second group attacked the garrison in the historic city of Bayamo. Intended to spark a national rebellion against Batista, the attacks of July 26 instead ended disastrously. Not only did they fail to rouse the public, but many of the attackers were captured, tortured, and shot. Castro and a few men from his group managed to escape into the nearby mountains, and their lives were ultimately spared thanks to the intervention of Santiago de Cuba's Roman Catholic archbishop, Enrique Pérez Serantes.[5]

During his October 1953 trial, Castro read from a manifesto he had penned entitled "History Will Absolve Me." In the document, he outlined his political program, citing the restoration of democracy as one of his primary goals.[6] Despite its failure, the bold and dangerous Moncada attack against Batista made Castro a national figure. Moreover, the intervention of a Catholic archbishop on his behalf, as well as his stated political agenda, gave him credibility with middle- and upper-class democrats and Catholics. In the end, Castro was sentenced to fifteen years in prison on the Isle of Pines.

Castro and his companions were released from prison in May 1955 after an amnesty was granted by President Batista, who had restored the 1940 Constitution the year before and subsequently rigged the 1954 election to give himself four more years in office. Castro received a hero's welcome from supporters in Havana, but decided to leave Cuba soon afterward to continue his struggle from abroad. Before departing for Mexico, where he would prepare his next move, he brought his followers together and created what became the 26th of July Movement (Movimiento 26 de Julio; named in commemoration of the Moncada attacks).[7] At around the same time, other groups also stepped up their efforts against the Batista government. The University Student Federation, angry over Batista's refusal to agree to new (and fair) elections in the "Civic Dialogue" he held with his democratic opponents, set up the clandestine Directorio Revolucionario to fight the government more directly and violently. Other groups, such as those associated with the former political parties, likewise escalated their efforts against the Batista regime.[8]

In Mexico, Fidel Castro and his brother Raúl organized the 26th of July's members and supporters abroad, which now included Ernesto "Che" Guevara,

the intensely anti-American Argentine physician and self-styled revolutionary who had served in Jacobo Arbenz's left-wing government in Guatemala.[9] The 26th of July members busied themselves in Mexico raising money, collecting arms, and training for an invasion of Cuba. Castro, while still proclaiming his adherence to the ideals of Eduardo Chibás, gradually separated his young movement from the Ortodoxo Party.[10]

Again overestimating the likelihood of a national rebellion, Castro launched a second major strike against the Batista government that ended nearly as disastrously as the first. In November 1956, eighty-one men under Castro's command departed from Tuxpan, Mexico, for their "invasion" of Cuba aboard the yacht *Granma*. Their landing at Oriente was timed for November 30, in conjunction with an uprising in nearby Santiago de Cuba led by Frank País, a local 26th of July rebel. The País-led rebellion was launched as planned and enjoyed success for two days. The Castro party, however, failed to land, and Batista quelled the País insurrection. On December 2, two days behind schedule, the Castro group finally landed in Cuba. In what was nearly a complete debacle, the *Granma* was spotted by a fighter plane, set upon by a naval frigate, and forced to land at Playa los Colorados, a swamp. The rebels abandoned most of their equipment, struggled to reach dry land, and desperately fled the army through nearby sugarcane fields. A number of them were captured or killed as they tried to reach the Sierra Maestra, and others escaped the region altogether. By the time the rebels regrouped in the mountains, fewer than fifteen remained.[11] Once again, the Cuban people did not rise to support Fidel Castro.

Back in Havana, Batista reacted to the violence in Oriente by rounding up suspected revolutionaries, instituting press censorship, suspending constitutional guarantees, and closing the University of Havana. Over the Christmas and New Year's holidays, as the remnants of Castro's rebels regrouped in the Sierra Maestra, 26th of July cells in the cities, using the terror tactics that had become so common in Cuban politics, set off bombs in public places (in many cases harming innocent civilians; see page 5).[12] Batista, responding with ferocity as well, rounded up and summarily killed suspected opposition activists. He did not, however, launch a major offensive against the Castro-led group

▼

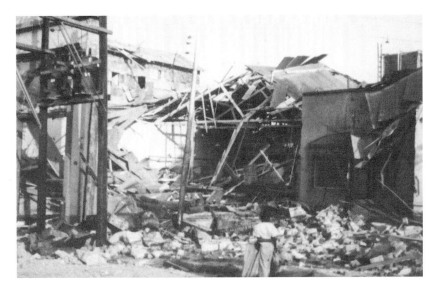

The destruction caused by a rebel-planted bomb at a sugar mill during the civil war.

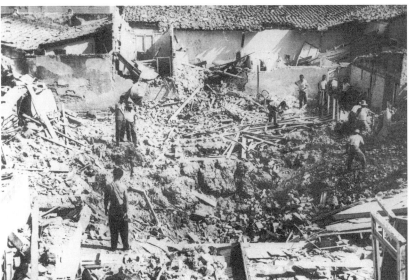

The aftermath of a rebel bombing, this one in the heart of Bayamo.

in the Sierra Maestra, apparently feeling the tiny rebel band would ultimately disintegrate in the harsh jungle terrain. Far from disappearing, the Castro rebels launched a successful surprise attack against the tiny La Plata garrison in mid-January 1957. Although little more than a skirmish, La Plata gave Castro's group a taste of victory and provided it with much-needed armaments. Over the next few weeks the rebels had some minor clashes with military patrols in the Sierra Maestra, but Batista continued to make very little effort to snare the minuscule rebel army, which numbered only eighteen men by mid-February.[13]

In early 1957, in what was perhaps the most fruitful move of his political career, Castro sought an interview with a foreign press correspondent. A few weeks later, his people smuggled the left-leaning veteran journalist Herbert Matthews of the *New York Times* into the Sierra Maestra. During the visit, the small group of rebels exaggerated the number of arms they possessed and made grossly fraudulent claims to Matthews about battles they had fought against Batista[14]—all of which the sympathetic reporter recorded as fact. Raúl Castro, in a move that must have seemed hilarious to his fellow rebels, paraded the same men in front of Matthews several times, leading him to believe the rebel army was much larger than it actually was.[15] When Matthews was preparing to leave, Fidel Castro told the reporter, "we have the whole area surrounded, and we will get you out safely."[16] As Georgie Anne Geyer aptly stated in her work, *Guerrilla Prince,* "Matthews thought he was in a jungle, and, in truth, he was: a jungle of obfuscation and deliberate deceit."[17]

The Matthews story, which received extensive publicity, was published in three articles, the first one appearing in the *Times* February 24, 1957, Sunday edition. Activists in Cuba smuggled copies into the island, and the Cuban press ran the full story in Spanish translation when Batista lifted press censorship shortly afterward. In the articles, first and foremost, Matthews confirmed that Fidel Castro was still alive (the government had given the impression that the rebel leader was dead).[18] More important, he painted Castro and his men as a heroic group of young, idealistic rebels who, against a vicious enemy, were winning a war to achieve the freedom of their country. The romantic image of Castro painted by the articles, reminiscent of the sensationalistic yellow journal-

ism that had characterized American newspapers during the Cuban War of Independence, catapulted the formerly obscure bearded rebel leader onto the international stage. "Just as the Hearst press helped to make the Cuban Revolution in 1898," wrote historian Paul Johnson, "so the *Times* sponsored Castro."[19] Without a doubt, the Matthews articles (and the reporter's implicit advocacy) gave Castro political traction at the most critical juncture of his career and did more to help his struggling movement than any other single event.

The Matthews articles and subsequent support from the *New York Times* led other media outlets, including American television, into the Sierra Maestra.[20] The coverage provided the world with a steady diet of Fidel Castro, who was always depicted romantically as a disinterested, selfless freedom fighter. The carefully crafted, media-inspired Castro myth became so instrumental in gathering political and financial support for the 26th of July Movement that Che Guevara later commented, "The presence of a foreign journalist, American for preference, was more important for us than a military victory.[21] The favorable publicity also captured the imagination of foreign intellectuals and university students, who became infatuated with the idea of a group of bearded, idealistic rebels fighting an evil dictator in a faraway and exotic land. Riding the wave of public excitement, local 26th of July organizations in the United States and Latin America succeeded in raising a great deal of money for the movement and gaining ready access to media outlets, which were often more than eager for news of the revolution.

Also in early 1957, Civic Resistance, an organization of middle- and upper-class Cubans eager to oust Batista and reestablish the 1940 Constitution, was formed. Although technically independent of the 26th of July Movement, Civic Resistance was, in fact, a front organization used to conduct propaganda and raise money for Castro in Cuba.[22] It eventually abandoned its policy of nonviolence and joined the underground war against Batista in Cuba's cities. Urban warriors of the Civic Resistance fought alongside the 26th of July's urban cells, the Directorio Revolucionario, associations connected to the democratic political parties, and a variety of smaller resistance groups.[23] The urban underground groups (mostly middle class in nature) engaged in propaganda, kidnapping,

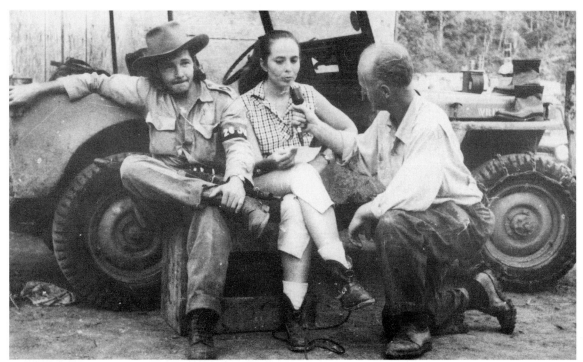

Raúl Castro and Vilma Espín talking to one of many journalists who visited the Sierra Maestra to report on the bearded rebels. One correspondent, Robert Taber of CBS News, ultimately gave up news reporting to become a leader in the Communist-leaning, pro-Castro "Fair Play for Cuba Committee" in the United States.

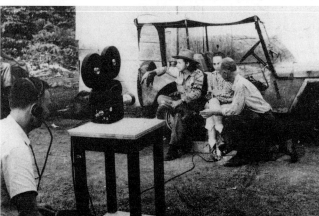

Raúl Castro and Vilma Espín talking to a journalist in the Sierra Maestra.

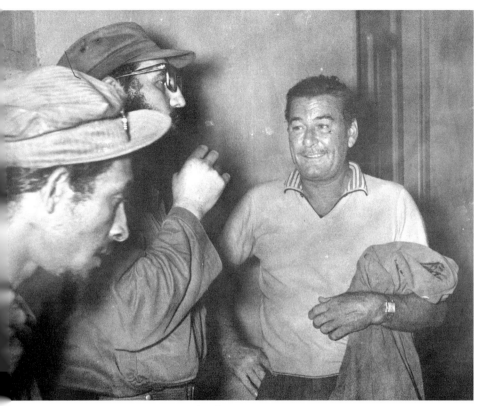

As Castro's war was sensationalized in the international press, a long succession of media luminaries visited the rebel army. Here, Fidel Castro discusses politics, ideology, and strategy with movie star Errol Flynn.

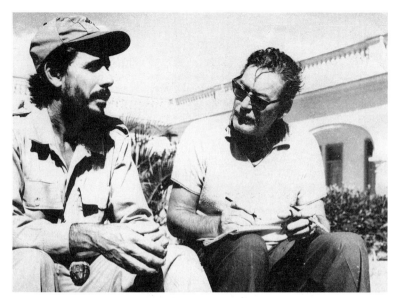

Errol Flynn takes notes for a movie project, *Rebel Girl*.

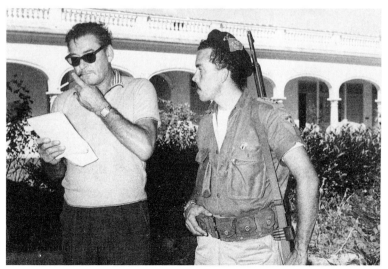

Rebel Captain Pepin López during an interview with Errol Flynn.

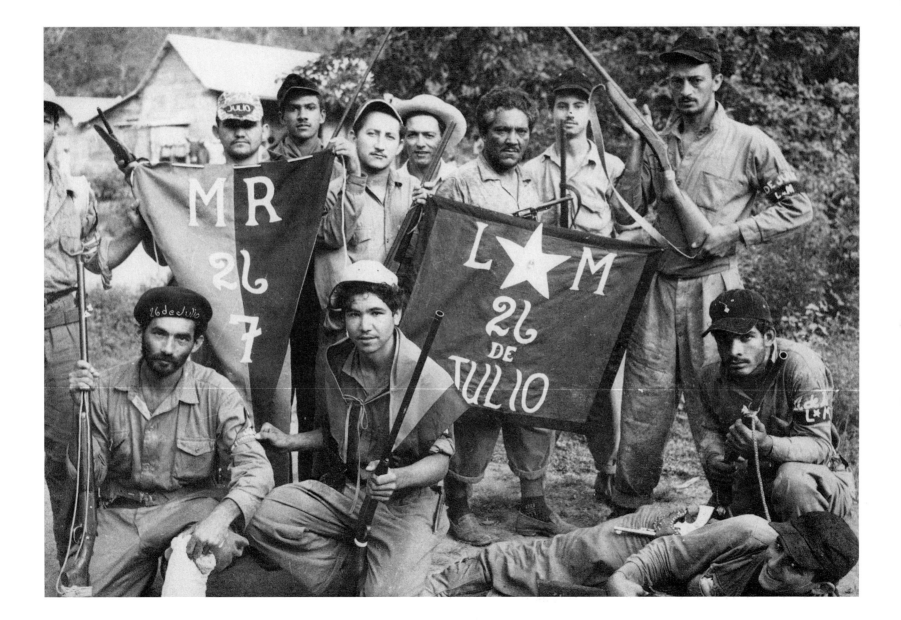

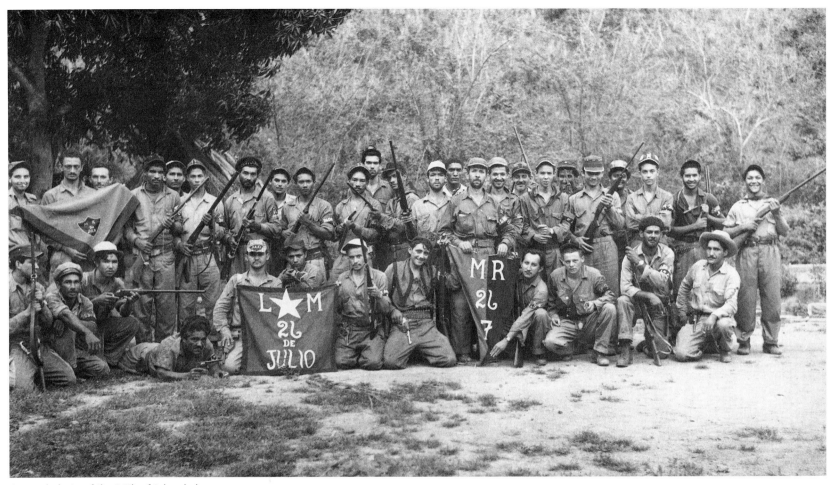

A posed photo of the 26th of July rebels.

Facing page: Many in the United States and
around the world were infatuated with the
idealistic 26th of July rebels.

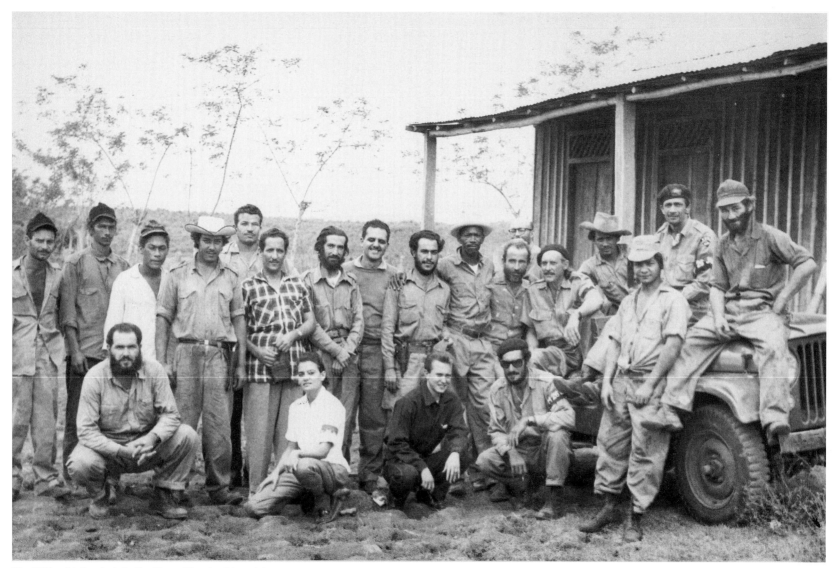

The 26th of July rebels in the Sierra Maestra Mountains.

bomb planting, and sabotage.[24] Because they confronted the Batista regime more directly, the urban fighters suffered a much higher death rate than the small group of mountain guerrillas who, paradoxically, received the lion's share of attention from the international press. As the most direct targets of the government's retaliatory strikes, members of the urban groups were frequently victims of torture and gangland-style murders by Batista forces. Noted Cuba scholar Jaime Suchlicki underscores the decisive role of the urban fighters in the anti-Batista struggle, stating, "It was the work of the urban underground more than anything else that brought about the downfall of the [Batista] regime."[25]

On March 13, 1957, a number of Directorio Revolucionario members (as well as members of the pro-democracy Auténtico Party) were killed when they tried to assassinate Batista in a brazen daytime attack on the Presidential Palace. Unaware that the palace attack had failed, José Echeverría, the head of the Directorio Revolucionario, was killed by police as he and a group of companions were en route to the university after leaving a popular radio station they had temporarily seized to announce Batista's death. The assassination attempt led to a wave of terror against Batista's enemies. Military death squads created fear among the youth in the cities, but popular opposition to the government grew as details of the Batista regime's grotesque assassination strategy came to light.

Echeverría's death weakened the Directorio Revolucionario and left the 26th of July Movement the strongest insurrectionist group on the island. Young Cubans who wanted to take direct action against the Batista government, or who were just seeking romance and adventure, became increasingly attracted to Castro's movement. In May 1957, Castro's mountain-based rebel army, its ranks now swelled to around 130, launched a well-planned attack against the small coastal army post of El Uvero on Babún family property. In the space of a few hours, the rebels overwhelmed the post and melted back into the mountains, taking with them all the supplies they could load aboard one of the Babún family trucks.[26] This small battle, the first significant victory for the rebel army, provided an important morale boost to the mountain fighters and energized anti-Batista forces across Cuba.[27]

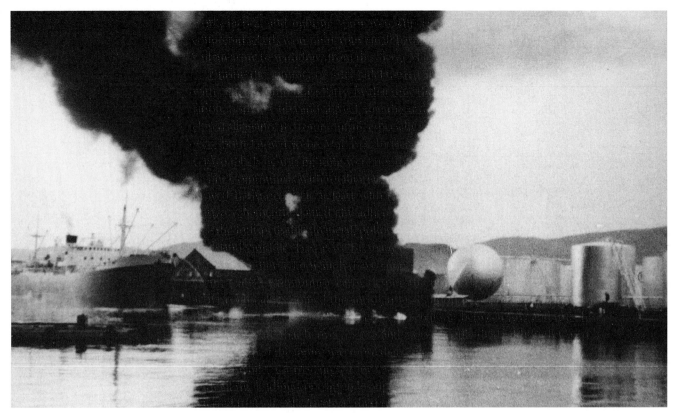

Fires, set by anti-Batista rebels as part of
their sabotage campaign, raged from one
end of the island to the other, killing many.

Facing page, top: During the last three months
of 1958, the rebels severely disrupted transpor-
tation between Havana and the three eastern
provinces.

Facing page, bottom: A train captured by rebel
forces in Oriente province.

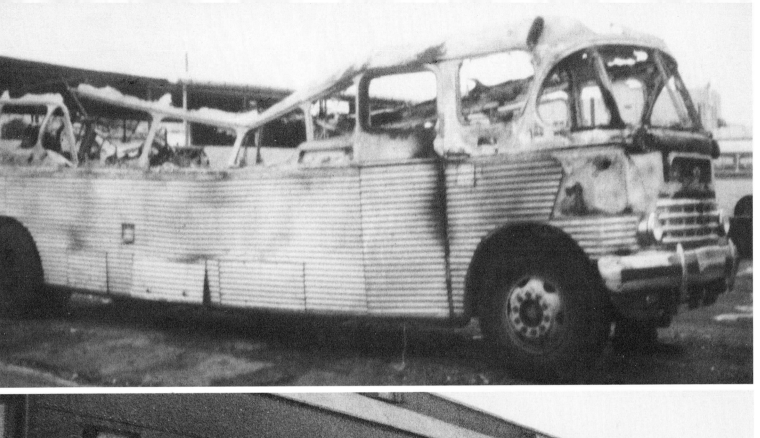
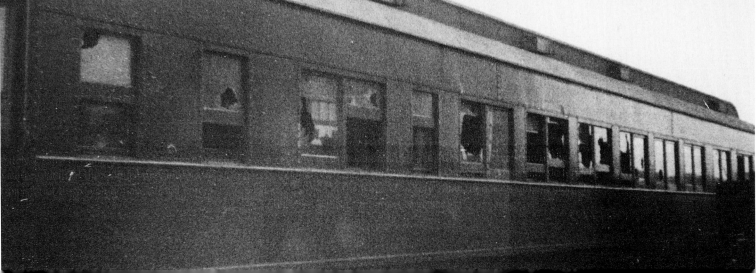

Rural as well as urban groups
committed acts of sabotage.

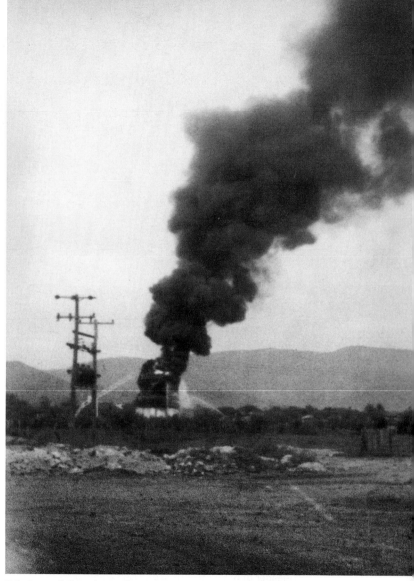

Sabotage of the urban infrastructure continued.

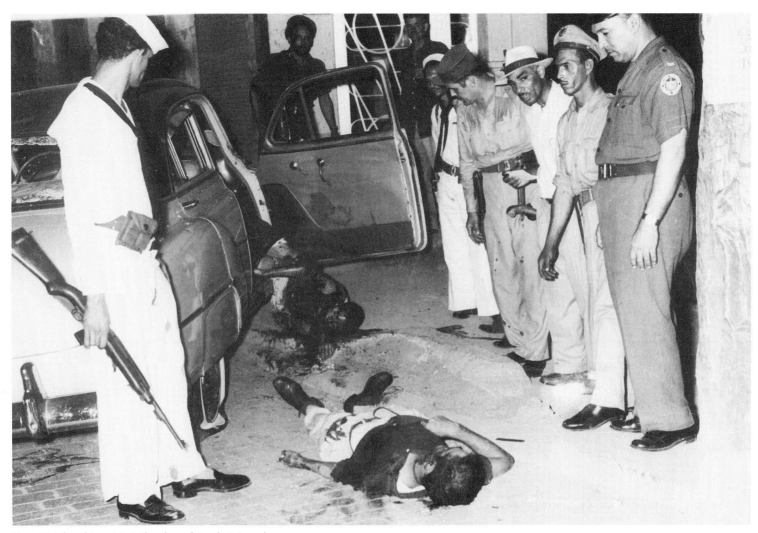

Floro Vistel and Josué País (brother of Frank País and co-leader of the local 26th of July cell) were assassinated while driving in the streets of Santiago de Cuba.

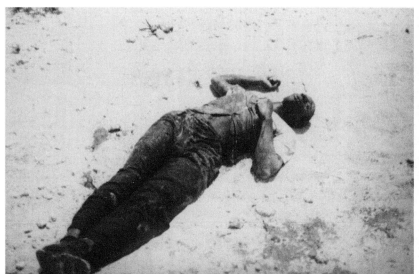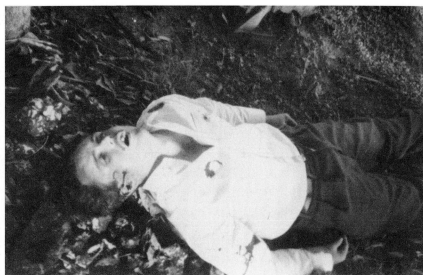

As the revolution gained momentum, murders of suspected rebels or rebel sympathizers increased.

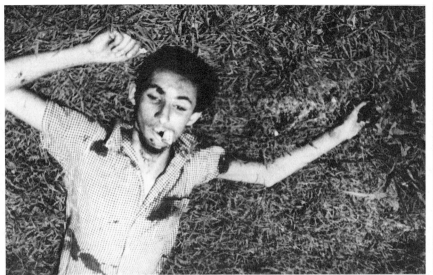

It was common for the bodies
of young men shot to death to
be found alongside a road.

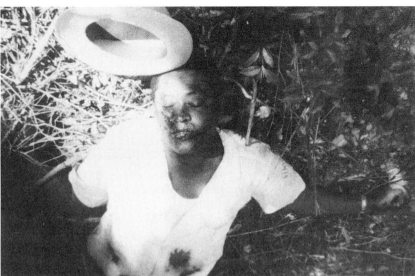

A man murdered as an
alleged Castro supporter.

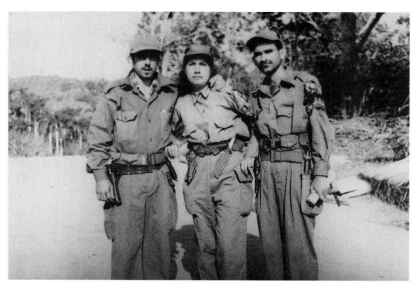

Many signed up to be part of the effort to overthrow Batista.

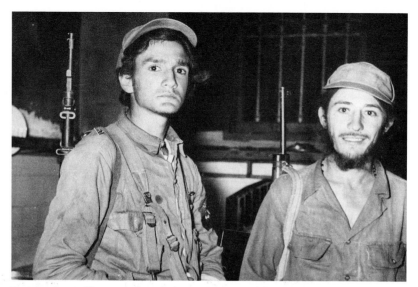

Teenaged guerrillas ready for action.

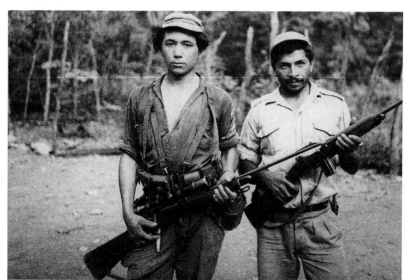

People from all sectors of Cuban society, including these young peasants, joined the small guerrilla army.

By the summer of 1957, Castro's rebel force had grown to two hundred men and women and commanded many parts of the Sierra Maestra.[28] Fidel Castro's apparent goal now was to stay alive in the mountains of Oriente and to remain the national (and international) symbol of the anti-Batista struggle. Accordingly, Castro deliberately kept the rebel army out of the enemy's reach and engaged in only low-risk attacks (and sabotage) whereby it could gain publicity, rattle Batista's forces, or steal weapons. With the 26th of July's propaganda machine effectively perpetuating the romantic Castro myth in Cuba and abroad, and the much larger urban forces doing the brunt of the fighting and dying, Castro hoped that the lazy and corrupt forces propping up Batista would become frustrated and demoralized and ultimately implode. He could then sweep in to fill the void. This strategy, largely psychological, proved enormously successful. Batista, perhaps unwittingly, also contributed to its success by waiting too long to use all the military power at his disposal to hunt Castro down.

By early 1958 Fidel Castro began to act as the de facto ruler over the parts of the Sierra Maestra he occupied, referring to it as Cuba's Territorio Libre (Free Territory). The mountain guerrilla world by then included a repair shop, an armory, a hospital, a shoe factory, bread ovens, and a lecture hall.[29] In February, the rebels even established their own mountain-based radio station, Radio Rebelde, to communicate directly with the Cuban people. (The modern radio transmitter was provided and smuggled into the Sierra Maestra for the rebels by the Babúns.) The broadcasts began defiantly, "Here, Radio Rebelde, transmitting from the Sierra Maestra in Cuba's Free Territory."[30] Many locals, especially peasants who had been mistreated by the Rural Guard, grew to sympathize with the rebel cause. Others cooperated with them out of concern for their own well-being. Peasants suspected of being informers and rebels believed to be traitors were brutally executed on Fidel Castro's orders.[31]

Also in 1958, opposition groups in Cuba launched a campaign to pressure the U.S. government to stop arms shipments to Batista. Powerful individuals in the U.S. State Department sympathetic to the cause managed to have an arms embargo enacted in March. The U.S. government then ordered Batista to withdraw from combat all the weapons his government had received through the

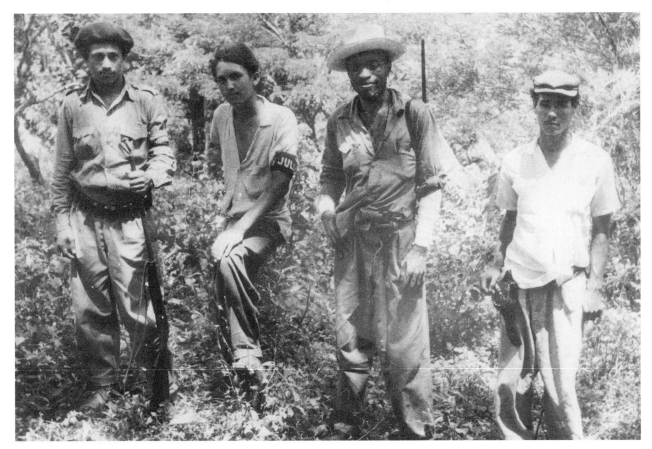

Opposition to Batista cut across racial lines.

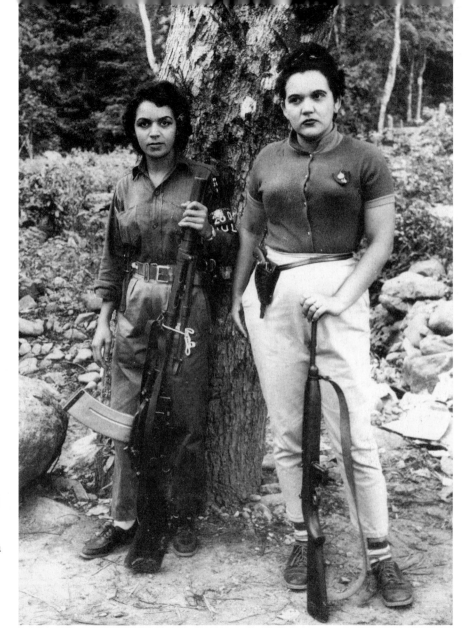

Rebel Lidia Doce (*right*) and a friend showing off their captured weapons. Doce died fighting Batista forces a few days after this photograph was taken.

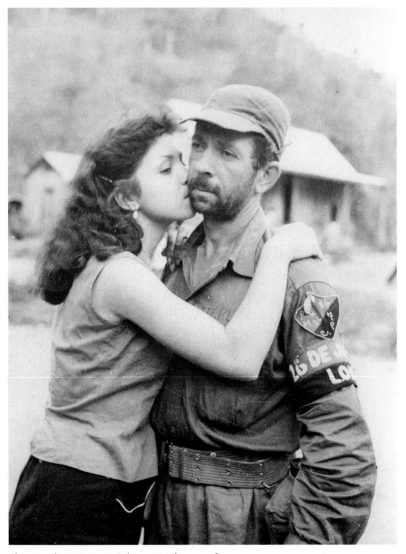

The popular movement drew people away from their loved ones.

A new recruit could easily drive a few miles out of Santiago de Cuba in the afternoon, and by the next morning be wearing a 26th of July uniform.

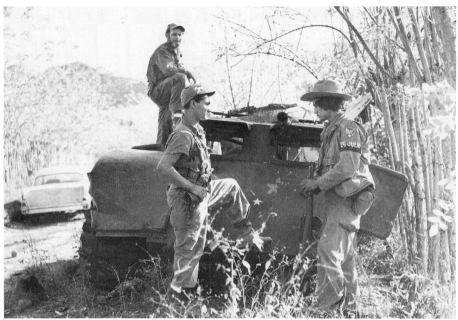

The Dragon I was a makeshift tank made from a tractor with steel plates welded to it. Forces under the command of Camilo Cienfuegos used it with great effectiveness.

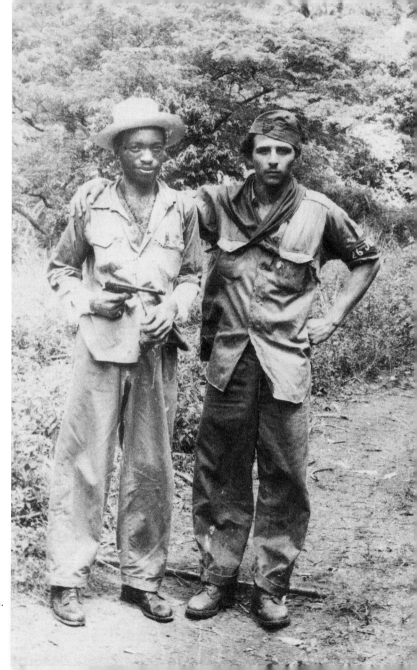

Two rebels posing after a small hit-and-run sabotage operation.

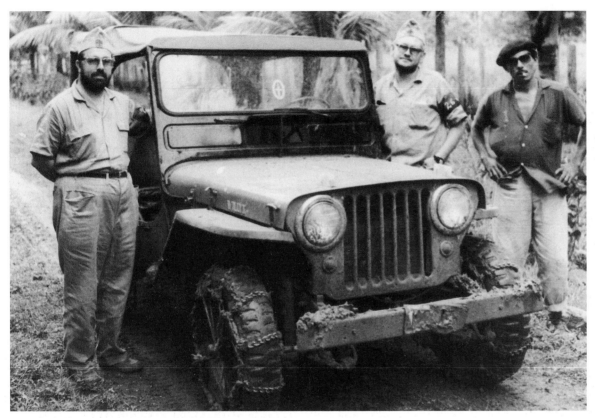

The rebel army had both Catholic and Protestant chaplains. Many of Cuba's Catholic lay organizations were active against Batista. Here, Catholic priests pose with their Jeep in the Sierra Maestra. Once in power, Castro launched an antireligious campaign and expelled a large number of Cuba's clergy.

Facing page: On weekends, family and friends would drive out to meet their loved ones fighting with the guerrillas, bringing food, religious items such as rosaries and scapulars, and good-luck charms.

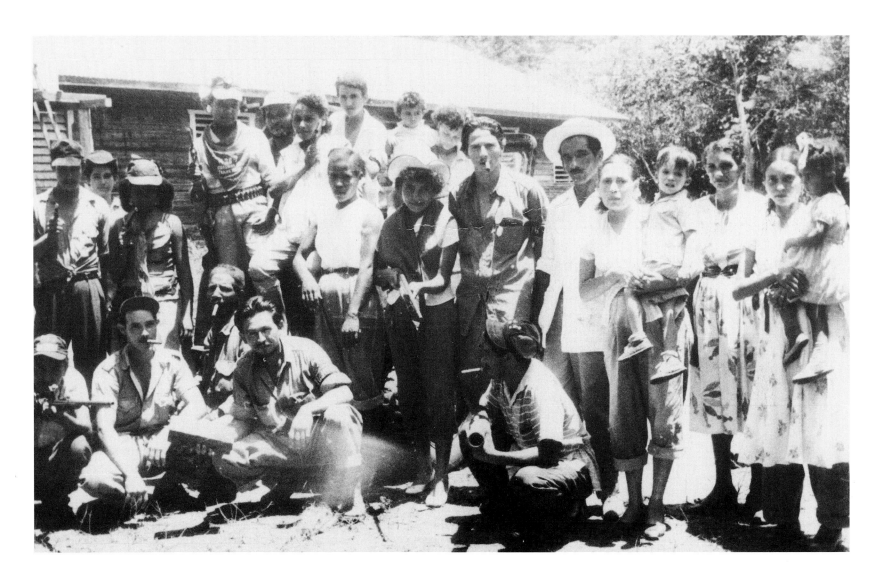

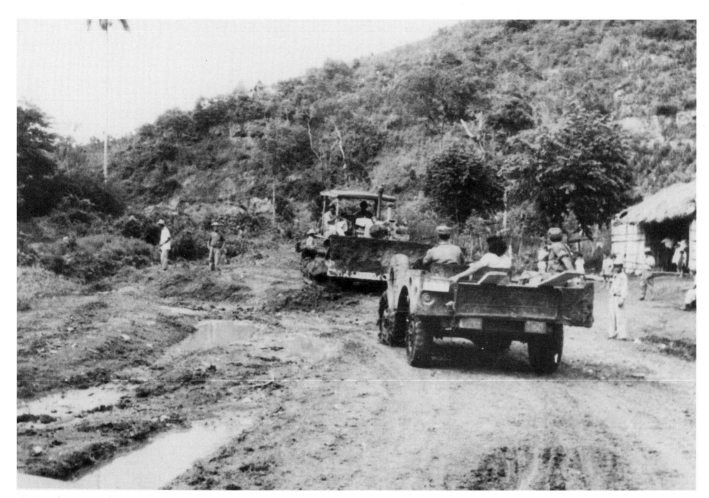

Getting from one place to
another in the rough terrain
necessitated heavy vehicles.

Military Defense Assistance Program, which was intended to arm Latin American nations for hemispheric defense.[32] The Cuban army and police, already weary from battling the opposition, now believed the United States had abandoned Batista and had indirectly transferred its support to the rebels. As a result, their morale and willingness to fight plummeted, beginning the implosion Castro sought. In addition to the arms embargo, the State Department asked the Immigration and Naturalization Service not to pursue Castro supporters in the United States who were sending money and arms to the rebels in violation of the neutrality laws.[33] Appreciating the significance of these developments, Castro declared "total war" on Batista and called for a national strike on April 9, 1958.

The strike of April 9 was a complete failure, as only a small handful of workers heeded Castro's call. Furthermore, Batista's forces killed a number of urban underground fighters and put many of their bodies on public display. Castro quickly recovered from this blow and, instead of backing down, consolidated his leadership and escalated the guerrilla war. His brother, Raúl, had earlier been sent into the Sierra Cristal of eastern Oriente to establish the 26th of July's authority over independent anti-Batista guerrillas there. During the summer of 1958, Raúl carried out spectacular kidnappings of Americans and Canadians, hoping his actions would pressure the United States, among other things, to stop providing fuel for enemy planes. Although the United States refused to be blackmailed and made no concessions, the sheer audacity of the actions brought Raúl Castro and the 26th of July a great deal of publicity. A capable guerrilla fighter Raúl Castro and his men encountered the regular army 247 times, captured six airplanes, intercepted five ships, and shot down three air force planes throughout the civil war.

Batista launched his only major offensive against Castro in May 1958, when he sent a large force into the Sierra Maestra to destroy the little rebel army—which still contained only around three hundred men. Although the offensive succeeded in squeezing the rebels into four square miles of territory, Batista's forces, unaccustomed to the terrain, became exhausted and their already low morale collapsed.[34] The 26th of July mountain rebels, whose intelligence net-

work, tactics, and fighting spirit were superior to those of their adversaries, counterattacked, won numerous small battles, and within a month forced the Cuban army to withdraw from the Sierra Maestra.

During the summer of 1958, Fidel Castro also made his first official contacts with Cuba's Communist Party. By that time there had already been heavy speculation, both in Cuba and abroad, that the 26th of July Movement had an undisclosed allegiance to Communism, especially since Che Guevara and Raúl Castro were both known to be Marxists. In fact, Batista frequently claimed that the Castro rebels he was fighting were not the liberal democrats they purported to be but Communists with totalitarian designs for Cuba. Although future events proved Batista correct, at least with regard to the 26th of July's inner circle, Castro vehemently denied any adherence to Communism (he didn't want to lose the indispensable financial, political, organizational, and moral support of the island's middle class, as well as many of the movement's own guerrillas, who would have never knowingly have supported a Communist cause).[35] In any event, Cuba's Communist Party, despite the objections of many 26th of July activists and allies, joined the anti-Batista coalition in 1958 and participated in the fighting. During the political crisis and civil war between 1952 and 1958, historians estimate that between 1,500 and 2,000 people died, although Castro's people claimed the figure was more than 20,000.

Meanwhile, Castro entered into a pact in Caracas, Venezuela, in July 1958 with all the leading opposition groups, except the Communists. The coalition referred to itself collectively as the Frente Cívico Revolucionario Democrático and promised to bring about Batista's downfall and the restoration of democracy in Cuba. The group chose well-known liberal lawyer José Miró Cardona as its coordinator, Fidel Castro as commander-in-chief of its armed forces, and Judge Manuel Lleó Urrutia as the president of Cuba in arms.[36] Being surrounded by such noted pro-democracy figures surely bolstered Castro's assertions of commitment to the constitution and democratic elections.

In August 1958, with Batista's forces substantially softened by low morale and a general reluctance to continue the fight, Fidel Castro finally went on the offensive. His troops began to encircle Santiago de Cuba, while a force under Che

Raúl Castro Ruz. Ultimately, Castro became first vice-president of the Council of State, first vice-president of the Council of Ministers, a four-star general, and minister of the Revolutionary Armed Forces.

A capable guerrilla commander, Raúl Castro Ruz was one of the traditional Marxists in the 26th of July Movement. His sadistic tendencies emerged in the wake of victory when, under his orders, more than a hundred Batista supporters were shot into a mass grave.

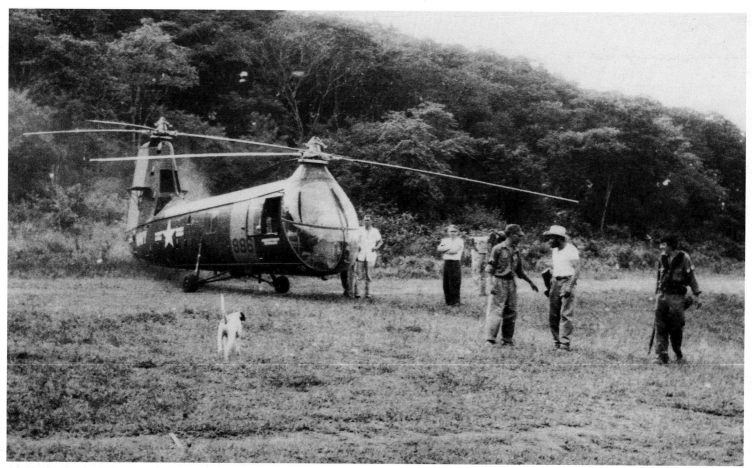

Raúl Castro's kidnapping of foreigners boosted
the image of the rebel army. U.S. helicopters
were used to ferry hostages and negotiators in
and out of the hills.

Facing page: Raúl Castro's Second Front became
known for its guerrilla tactics. Here the group
poses; the man at bottom left holds a *boqui toqui*
(walkie-talkie).

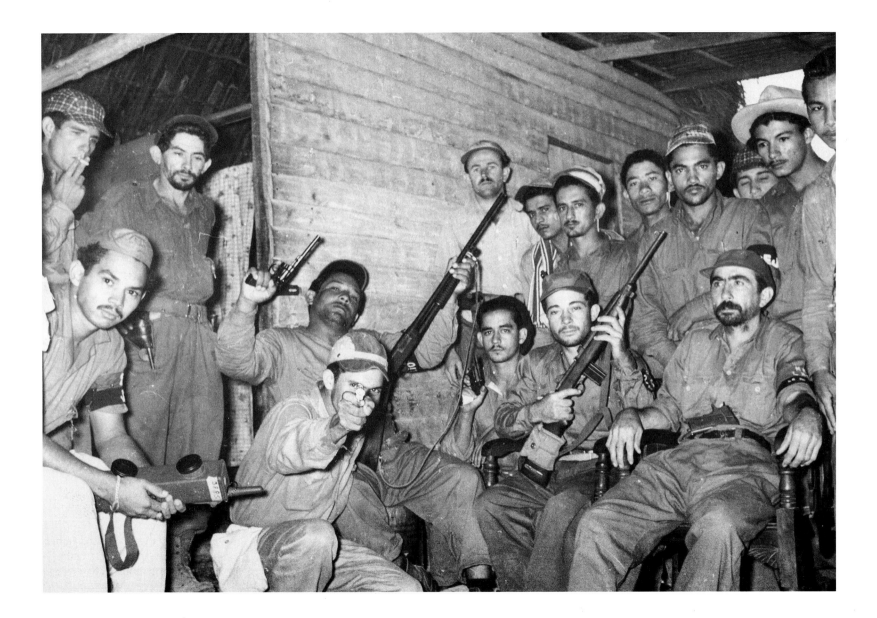

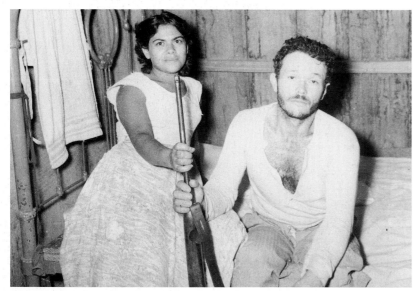

Besides the perils of war, natural perils,
such as malaria, took their toll. This man
in sick bay waits for a diagnosis.

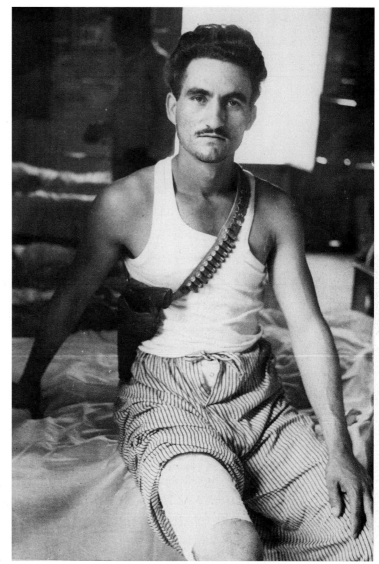

An injured fighter in the Sierra Maestra.

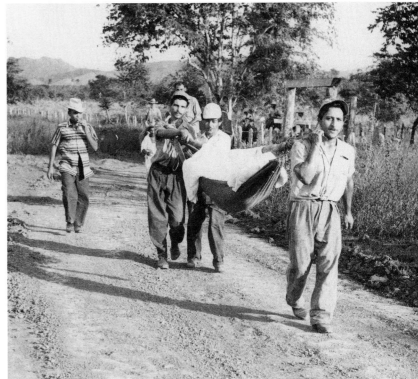

A body being taken for burial.

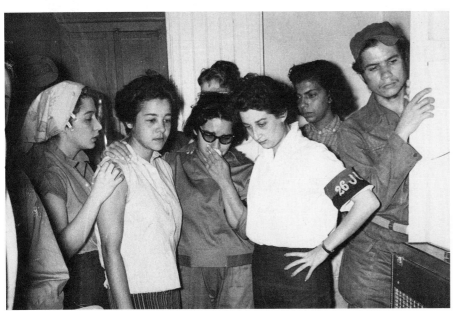

For the rebels, victory had a
high human cost.

An injured rebel.

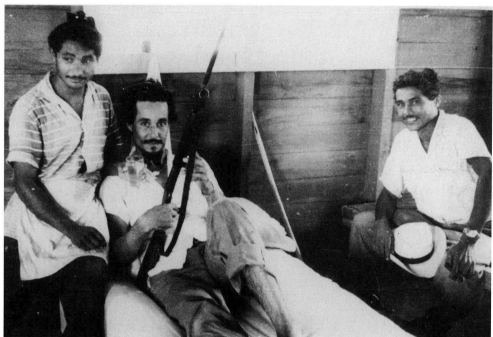

A wounded rebel in the field hospital near El Caney.

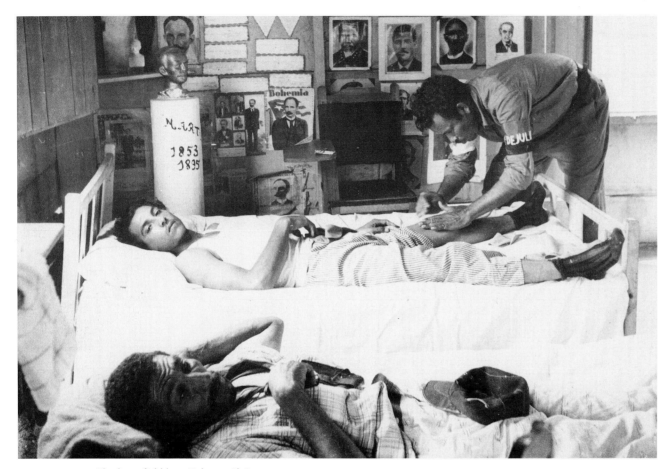

The busy field hospital near El Caney.

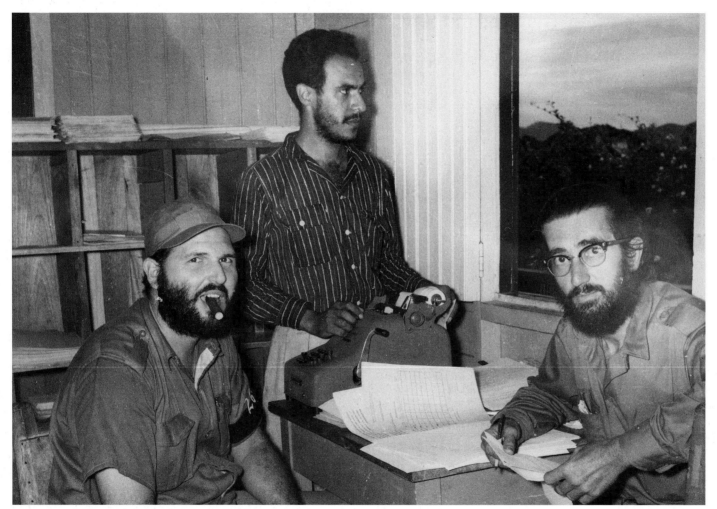

From left to right: Jorge Gomez, Adolfo Arrazola, and
Lt. René León, in charge of the rebel forces' payroll.
Gomez and Arrazola ultimately became disillusioned with
Castro after his rise to power and went into exile.

Guevara and Camilo Cienfuegos deployed west into Las Villas province to cut all communication between the two ends of the island. Guevara was also sent to establish the 26th of July's authority over the guerrilla army in the Sierra Escambray, which was made up of members of the Directorio Revolucionario and other coalition groups. Castro's forces tightened the noose throughout the fall as the November elections approached. Castro, not wanting an election to impede his road to power, called for the assassination of all the candidates and warned that anyone who tried to vote would be gunned down at the polling places.[37] The candidate from Batista's party, Andrés Rivero Agüero, predictably won the rigged election and was supposed to take office in February 1959. (Batista could not succeed himself according to the 1940 Constitution.) The public outrage over the sham election was considerable, increasing popular support for the revolution.

Batista's final collapse came in December 1958, before Rivero Agüero could even take office. In Las Villas, the forces under Cienfuegos and Guevara destroyed bridges and rail lines, and began to take over numerous towns. The Tercer Frente Oriental, headed by Castro subordinate Juan Almeida Bosque, encircled Guantánamo, and several officers of the Cuban army defected to Castro near Santiago de Cuba. With Batista's fall now only a matter of time, the ranks of the rebel army swelled to three thousand in December—ten times the size it had been earlier that year (several rebel leaders are shown in the photos on pages 44–54).[38] Government forces, completely demoralized and plagued by defeatism, were surrendering to far inferior rebel forces en masse after scarcely an exchange of gunfire. Having already lost the support of the United States and most of the Cuban public, Batista tried to make one last stand at Santa Clara, the capital of Las Villas. At Santa Clara, Che Guevara attacked an armored train that acted as the army's key command post and later derailed it with tractors from the local university's School of Agronomy. The Civic Resistance cells in Santa Clara attacked police, and by the last day of 1958 half the city was taken.

With Santa Clara on the verge of falling into rebel hands, Batista ordered some of his top commanders to a New Year's Eve celebration in Havana. At the party, he announced his resignation and later boarded an airplane for the Do

Guevara's forces succeeded in cutting communication between the two ends of the island.

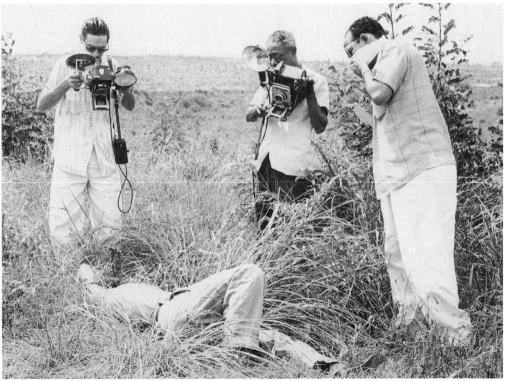

A crew apparently cataloguing the casualties.

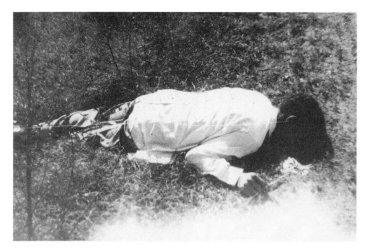

Nameless casualties of the civil war.

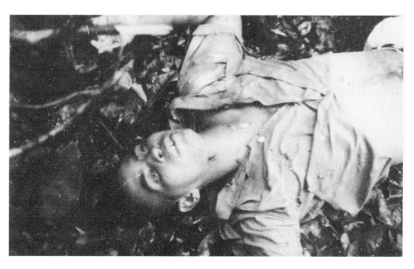

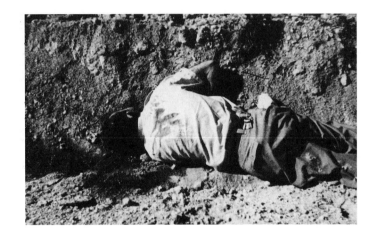

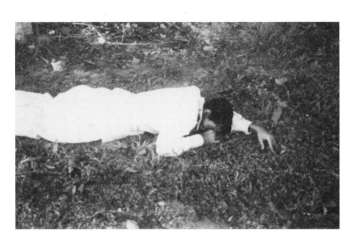
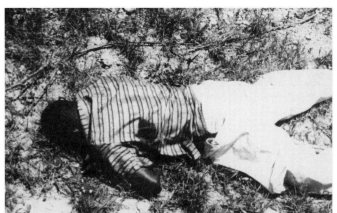
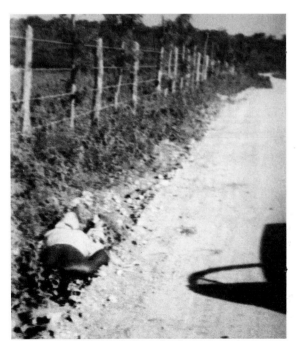

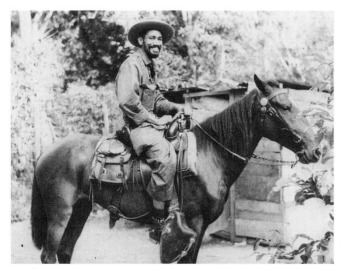

Future vice-president of the Council of State, Commander Juan Almeida Bosque, on horseback.

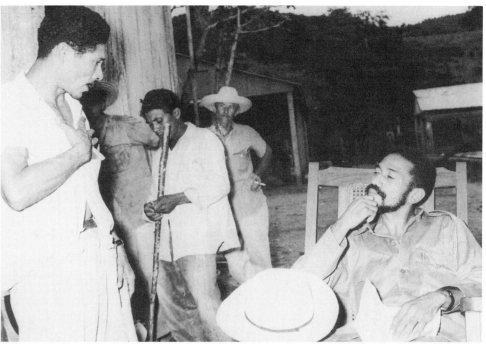

Commander Almeida resting and interviewing a new recruit.

Facing page: Rebel troops join forces before establishing a new front in Las Villas.

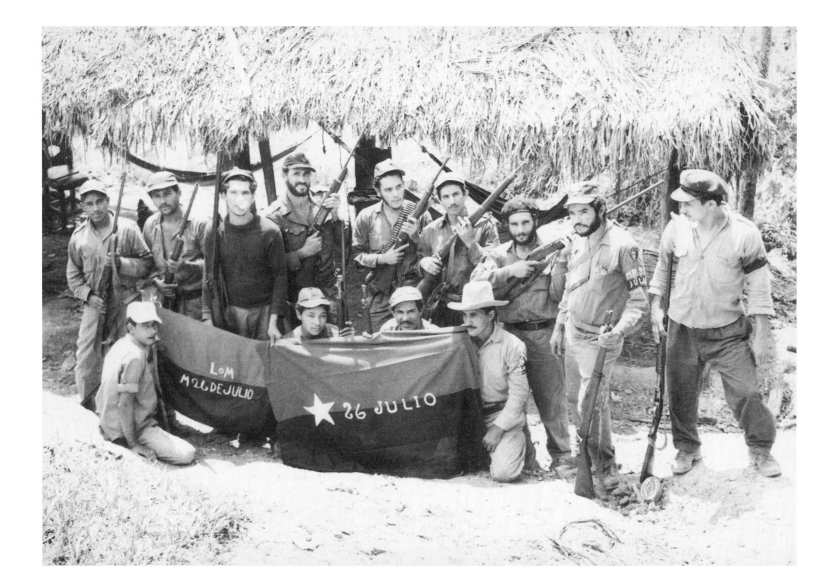

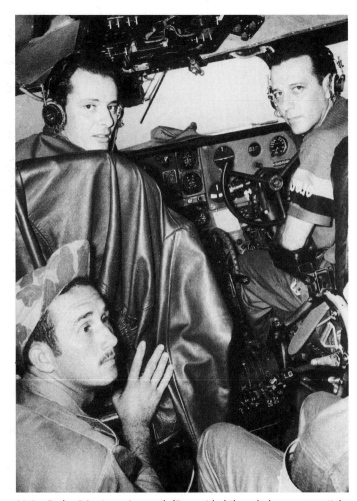

Major Pedro Díaz Lanz (*upper left*) provided the rebel army essential aerial assistance during the war against Batista and became chief of the Air Force after Castro's assumption of power. Six months later, suspecting Communist subversion of the revolution, he defected to the United States, where he testified before a U.S. Senate committee about the growing Marxist influence in Cuba.

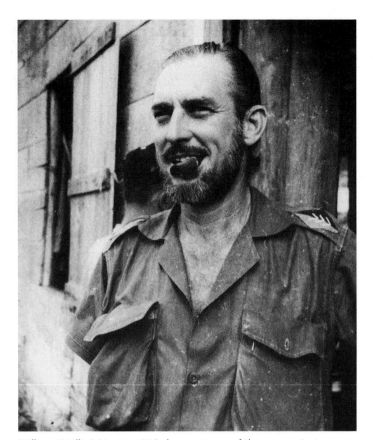

William "Willie" Morgan, U.S.-born veteran of the war against Batista on the Sierra Escambray front. He later entered the opposition against Castro and helped create a guerrilla army made up of ex-students and rebels to overthrow him (once again in the Sierra Escambray). He was arrested in 1960 and, accused of being a CIA operative, was executed in 1961.

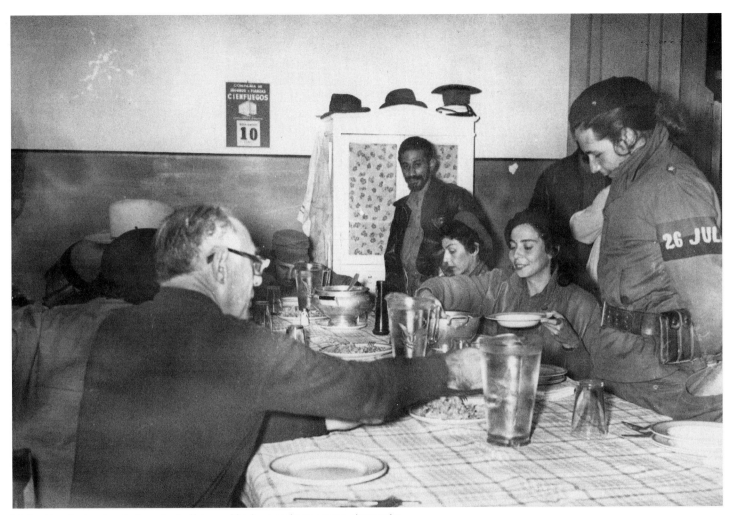

Melba Hernández, head of medical affairs and highest ranking woman during the guerrilla war, at mealtime in the rebel camp sitting next to Vilma Espín (*holding bowl*) and surrounded by Fidel Castro (*sitting, slouched, at the head of the table*), Raúl Castro (*standing, right, with 26th of July armband*), and Juan Almeida Bosque, commander of the revolution (*standing, behind Hernandez*).

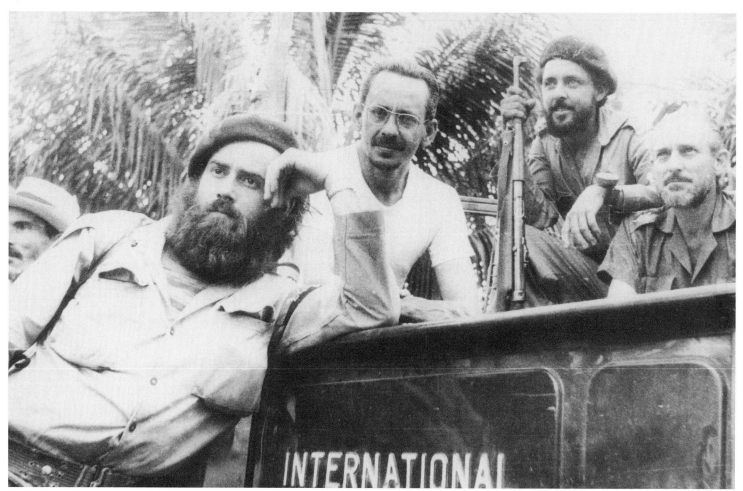

Rebels posing in a Jeep. *From left to right*: Future Communist leader Manuel A. "Barba Roja" Piñeiro, Oriente Fernández, Higinio "Nino" Díaz, and William Morgan. Díaz broke with Castro shortly before Batista's fall because of his concerns over Communist influence in the 26th of July Movement. He later helped form the MRR, one of the leading anti-Castro underground groups in Cuba.

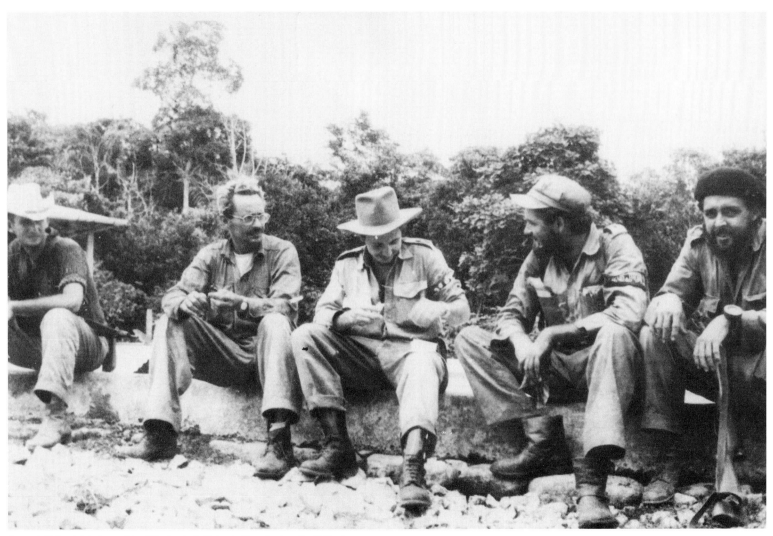

From left to right: An unidentified rebel, Oriente Fernández, Raúl Castro,
an unidentified rebel, and Nino Díaz, in northeastern Oriente province.

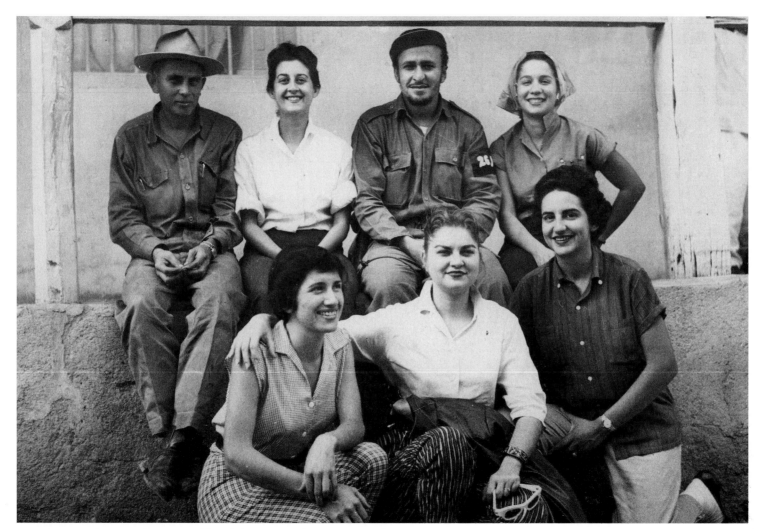

Maria Victoria Pérez Arias (*top, second from left*) was a teacher in Santiago de Cuba and an active sympathizer of the 26 of July movement. She was known to often carry munitions in secret from the city to the mountains.

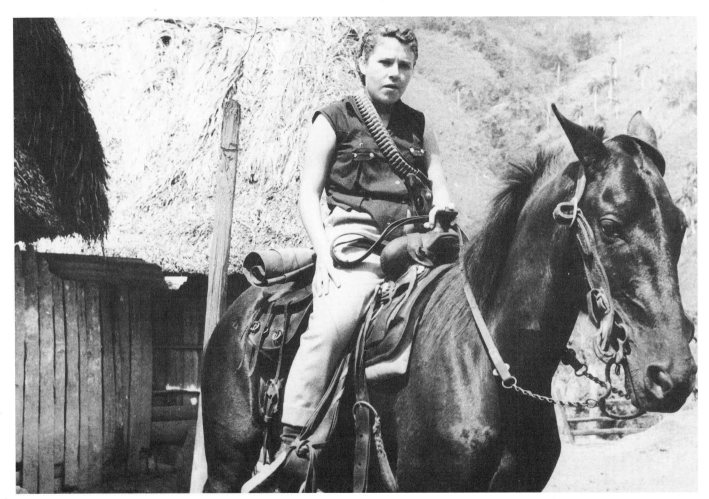

Haydee Santamaría Cuadrado, who ran the movement's Miami office during part of 1958. She participated in the Moncada attack, in which she lost both her boyfriend, Boris Santa Coloma, and her brother, Abél. She committed suicide on July 26, 1980, after announcing to a group of young revolutionaries that, in spite of her sacrifices, she was being ignored by the Castro government.

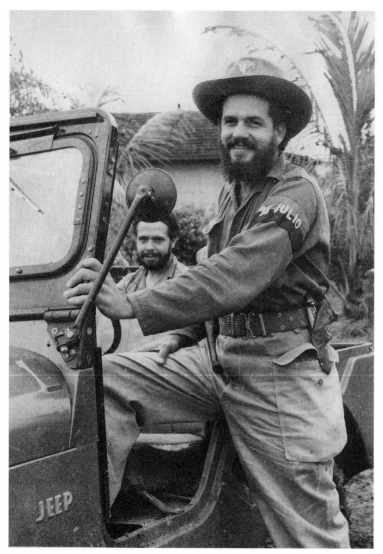

Adolfo Arrazola (inside the Jeep) and Antonio Enrique Luzón, both of whom later became disillusioned with Fidel Castro.

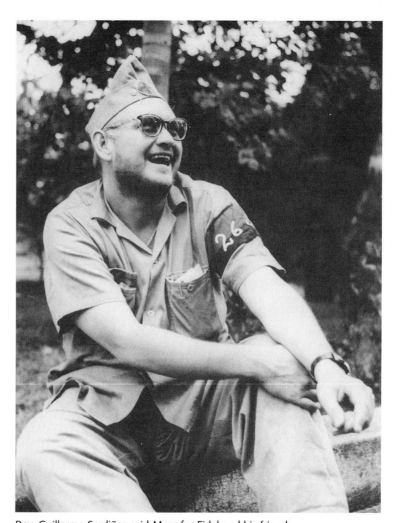

Rev. Guillermo Sardiñas said Mass for Fidel and his friends while in prison. Later, after obtaining permission from Cardinal Archbishop of Havana Manuel Arteaga y Betancourt, Sardiñas became chaplain of the rebel army. Fidel himself designated Sardiñas as commander of the revolution.

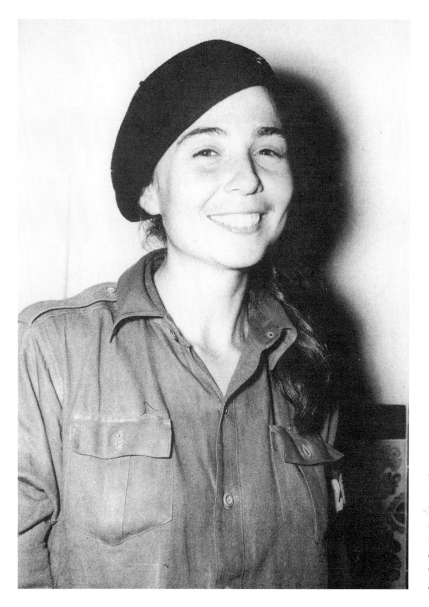

Vilma "Deborah" Espín Dubois was the daughter of an upper-class lawyer and held a chemical engineering degree from the Massachusetts Institute of Technology. She assumed an important leadership role in the revolution (including becoming assistant to Raúl Castro). She later married (and divorced) Raúl Castro, with whom she had four children. Espín was president of the Cuban Federation of Women (FMC), and a member of the National Assembly of Popular Power.

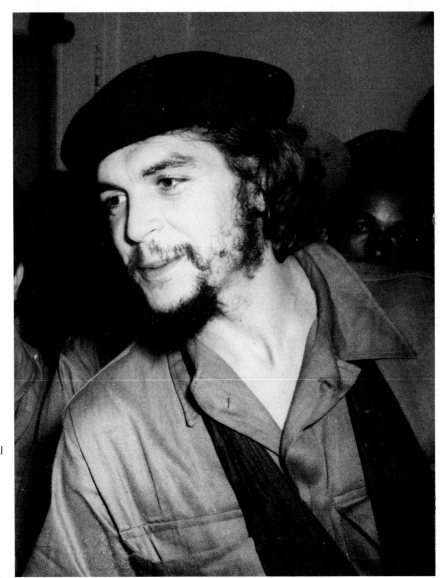

Ernesto "Che" Guevara, an Argentine national, was a medical doctor and international revolutionary. Introduced to Fidel Castro by María Antonia in Mexico City, he was one of the traditional Communists among the leaders of the revolution. He later headed the government's economic efforts as minister of industry and president of the National Bank of Cuba, before resigning in 1965. He was captured and killed in Bolivia on October 8, 1967, while trying to stimulate a peasant uprising there.

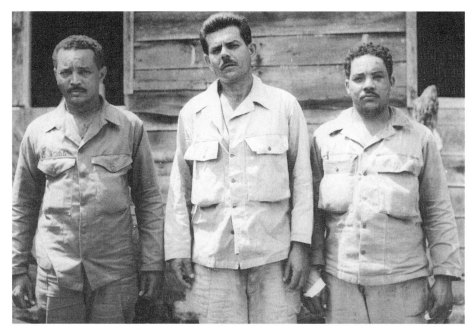

Three prisoners.

The modernized guerrilla tactics would later be copied around the globe.

minican Republic with a handful of friends, leaving thousands of supporters stranded. Those Batista associates with sufficient connections or means, which included those most responsible for the dictator's repression, fled during the night by airplane or boat. The Batista era was over.

On January 1, 1959, the police and army having virtually disappeared, 26th of July and Directorio Revolucionario members kept order on Havana's streets, which experienced less chaos than expected. The rebels remained courteous and polite, making a good impression on the residents of the capital. All over the island, rebels seized government buildings, police stations, army barracks, and communications facilities. Che Guevara took Santa Clara on New Year's Day, then proceeded to Havana, where his forces occupied key military points, including La Cabaña fortress. A force of seven hundred men under the popular Camilo Cienfuegos took over Campamento Columbia, Havana's main military garrison. In Oriente, Fidel Castro, who had been caught off guard by Batista's abrupt departure, entered Santiago de Cuba triumphantly. Batista's pro-democracy opponents in exile returned to Cuba, and low-level Batistianos remaining on the island were taken into custody. Across the nation the people rejoiced and threw their support behind the revolution and a democratic future for Cuba.

Castro's weeklong victory procession to Havana was conducted with a level of drama and pageantry that matched his personality and style. As Havana awaited him with anticipation, he stopped in numerous provincial towns and cities to receive the adulation of adoring crowds and to deliver impassioned speeches. When he finally arrived in the Cuban capital on January 8 with his troops aboard tanks, Jeeps, and trucks, he was received with unprecedented, near-hysterical celebration as Cuba's conquering hero. That night, as he delivered his address via national television, a white dove landed on his shoulder in what many took as an omen.

Even though the rebel "army" really had fought only two major military engagements (Batista's 1958 offensive and Santa Clara), with minimal casualties, the mythical image of Castro created in the Sierra Maestra, amplified now by Batista's flight and the triumphal march across Cuba and into Havana, ensured that Castro would remain the revolution's most popular leader. Castro's extraor-

dinary charisma and mesmerizing speeches, combined with the national euphoria over the successful revolution, brought hundreds of thousands of formerly neutral Cubans to support him. Revolutionary leaders, taking full advantage of the nation's emotional state, continued to encourage a cult of personality around Cuba's new messiah. Placards reading "Thank you, Fidel," and signs hung on doors reading "Fidel, this is your home" became common. Hugh Thomas, a leading authority on the period, correctly stated that "while before 1 January he had only a handful of followers, within weeks many thousands believed that he could do no wrong."[39] The momentum Castro established also allowed him to ignore his promises to other resistance groups in the Caracas Pact.

Among the new regime's first acts were to abolish political parties, concentrate all power in the cabinet, and postpone the promised elections for eighteen months.[40] These moves led many, including numerous revolutionaries who saw past the emotional frenzy of the moment, to become suspicious about Castro's true intentions. They began to wonder if they had been duped and the rumors of a Communist conspiracy were true. Contributing to these fears was the wave of revolutionary terror the Castro regime unleashed during its first weeks in power. Sham trials conducted before vindictive, bloodthirsty crowds shouting "*¡Paredón!*" (To the execution wall!) were followed by firing-squad executions. The total lack of legal process, as well as the bloodlust encouraged at the popular level, revolted true democratic reformers. The executions stood in sharp contrast to how Castro's people had treated captured enemy soldiers during the guerrilla war, when most were accorded rather humane treatment as prisoners. In defending the illegal postwar executions, Castro set the tone for the arbitrary and political nature of legal decisions in the new Cuba, stating, "Revolutionary justice is not based on legal precepts, but on moral conviction." Che Guevara, who as commander of La Cabaña fortress from 1959 to 1963 ordered the execution of hundreds of Cubans without trial, said, "To send men to the firing squad, judicial proof is unnecessary. These procedures are an archaic bourgeois detail. This is a revolution! And a revolutionary must become a cold killing machine motivated by pure hate. We must create the pedagogy of the paredón!"[41]

Also alarming to many Cubans in 1959 was the blatant Communist indoctrination of the armed forces by Guevara and other revolutionary leaders.[42] The first major alarm bells in this regard were sounded by Major Pedro Díaz Lanz, an anti-Batista rebel who resigned as Castro's chief of the Air Force in mid-1959 and sought asylum in the United States. His testimony before the U.S. Senate Internal Security Subcommittee that Castro was a tool of international Communism was derided in the U.S. press (including by Herbert Matthews and the *New York Times*), which tried to discredit Díaz Lanz and dismissed his accusations.[43]

In order not to lose the support of the middle class before he consolidated his power, Castro continued to deny that he was a Communist and filled his initial cabinet with well-known, anti-Batista liberal democrats. As he became more politically entrenched over the next several months, however, the liberals were purged and replaced by Communists and close Castro allies.[44] Some of Castro's own rebel comrades from the war were imprisoned or executed or died mysterious deaths when they openly questioned the direction the revolution was taking.[45] The most spectacular cases were those of rebel chief Huber Matos, who was given a twenty-year sentence in 1959 for questioning Castro's ties to Communism, and Camilo Cienfuegos, whose Cessna suspiciously disappeared between Camagüey and Havana a week after Matos's arrest. By the time it became obvious that Castro had abandoned the revolution's original ideals and was leading Cuba into Communism, he controlled the armed forces, had created an efficient system of internal state security, and had brought legions of new followers under his personal banner.

The battle lines between Communism and democracy in Cuba were firmly drawn in 1960. Soviet Deputy Premier Anastas Mikoyan visited the island in February, and the Castro regime subsequently established diplomatic relations and signed a commercial agreement with the Communist superpower. Also in 1960, Castro's government began taking over the island's public and private institutional structure. The labor unions were brought under Communist control, freedom of the press was permanently ended, and the government confiscated and monopolized all media, allowing it to conduct mass propa-

ganda and social indoctrination. The government also began to expropriate numerous private businesses, launched a fierce antireligious campaign, and ended the autonomy of the University of Havana. The promised elections, meanwhile, were replaced by the cynical slogan, ¿Elecciones, para qué? (Elections, what for?).[46]

Democratic opposition to the new regime quickly arose and included many people who had previously fought against Batista. Castro's political police pursued the activists, and those who were caught were executed or given decades-long sentences in the regime's nightmarish political prison system. In their entire history the Cuban people had never, even in the worst days of Batista, been subjected to such levels of violence by their government. Moreover, Castro's anti-Americanism, something his propaganda machine had skillfully concealed during the guerrilla war, surfaced as he delivered hysterical and incessant diatribes against the United States. Relations between Cuba and the United States were severed in January 1961.

Many who had helped Fidel Castro rise to power, especially the largely anti-Communist Cuban middle class, felt betrayed. In their estimation Castro had manipulated them with promises of democracy to get into power and then installed a Communist dictatorship. Mario Llerena, a one-time leader in the 26th of July's Committee in Exile, described Castro's manipulation as an "ideological sleight of hand," and stated that "without realizing it, the middle class was actually used as the disposable booster of the camouflaged Communist rocket until it reached its planned orbit in power. Then there was no longer need for a middle class."[47] Along with other sectors of the population, many middle-class Cubans found the prospect of living under a totalitarian system unacceptable. Parents were particularly alarmed when plans surfaced to shut down the island's schools and replace them with schools and youth programs that aggressively indoctrinated children in Communist militancy, atheism, and adoration of Fidel Castro. To them, the regime seemed prepared to take whatever measures were necessary to condition the next generation for its own political purposes, even if that meant an ideological (and, many feared, physical) separation of children from their families.[48]

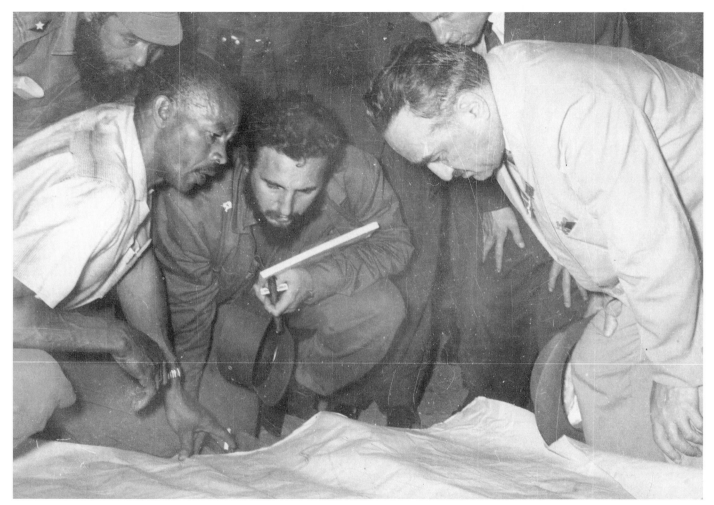

Fidel Castro and others looking at a map of Santiago de Cuba.

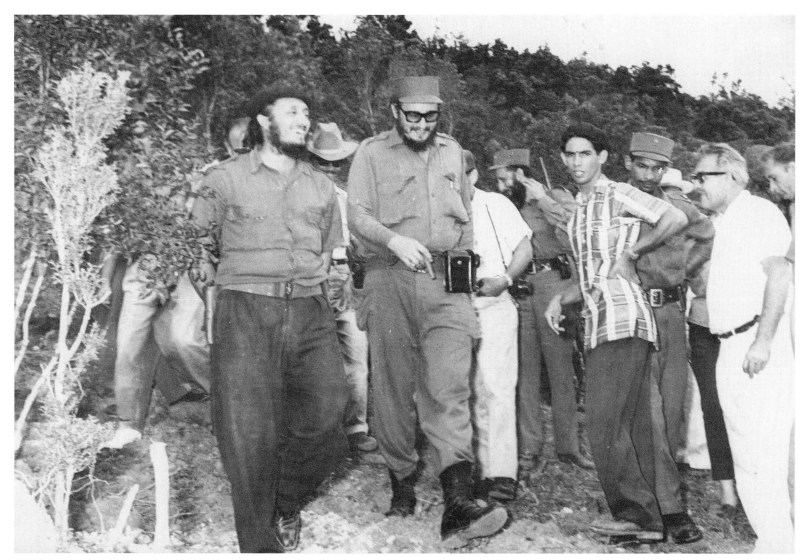

Fidel Castro in the vicinity of Santiago de Cuba.

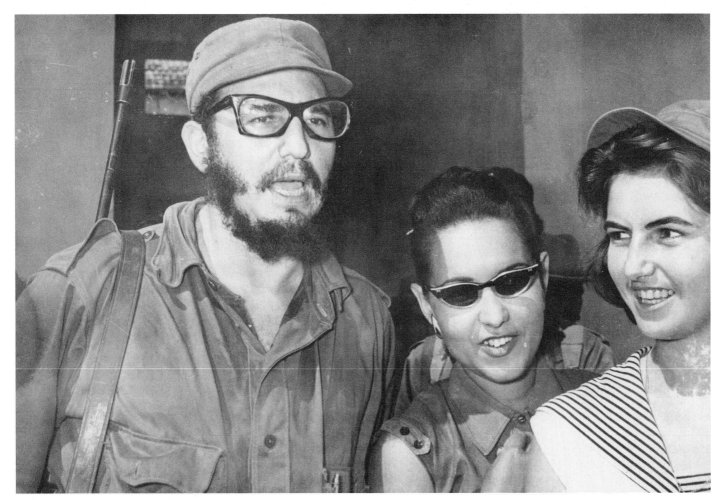

Fidel chats with young female supporters in Santiago de Cuba.

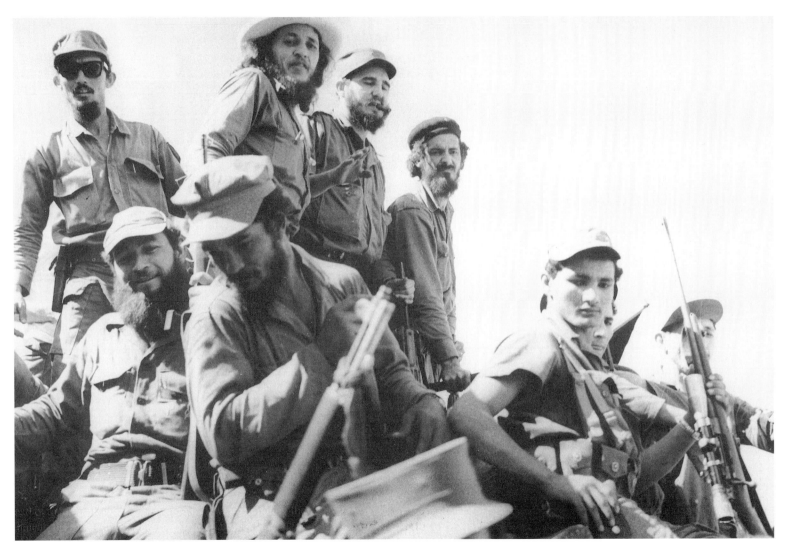

Fidel with other "Barbudos" (bearded ones),
during their final push to Santiago de Cuba.

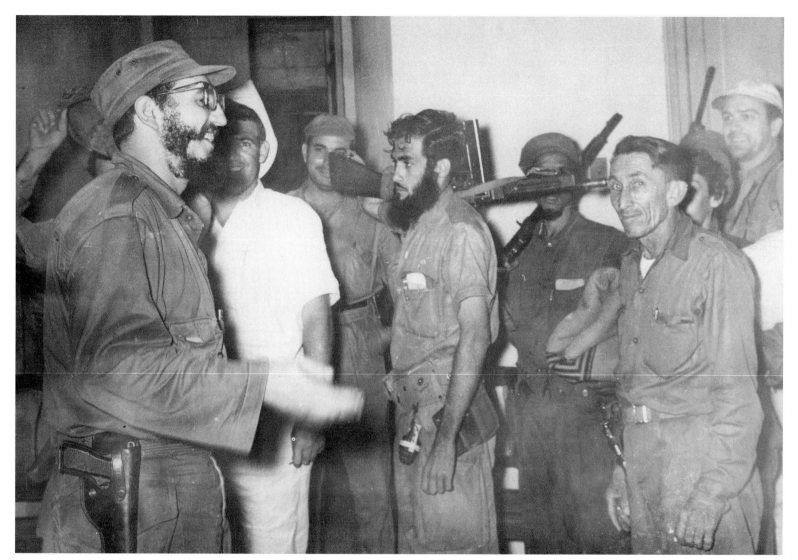

Fidel with fellow rebels and sympathizers in Santiago de Cuba.

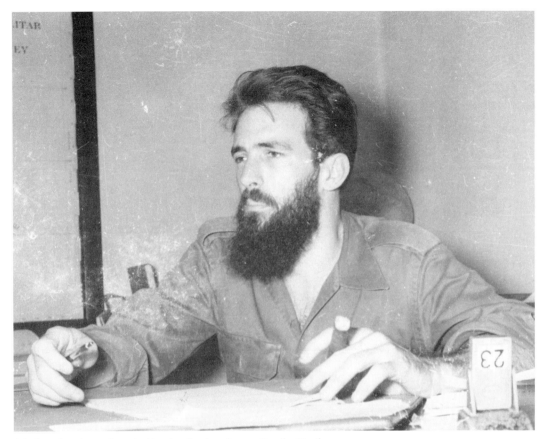

A beloved and popular rebel leader, the handsome Camilo Cienfuegos was reportedly upset at Castro's treatment of Huber Matos. A week after Matos was arrested, a Cessna airplane carrying Cienfuegos from Camagüey to Havana disappeared under extremely suspicious circumstances. Many Cubans, both in exile and on the island, are certain that Fidel Castro assassinated Cienfuegos.

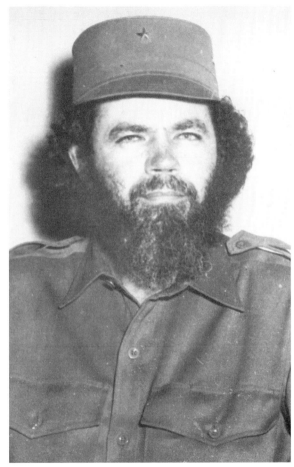

Rebel commander Huber Matos, the military governor of Camagüey, was given a twenty-year prison sentence by Castro in the fall of 1959 when he raised questions about the revolution's apparent turn toward Communism. After his release from prison in 1979 he went into exile and formed the anti-Castro group Cuba Independiente y Democrática (Independent and Democratic Cuba).

Raúl Chibás, ex-president of the Ortodoxo Party and brother of party founder Eduardo Chibás, was captured and imprisoned by the Batista regime. Later he received asylum at the Argentine Embassy in Havana and organized arms shipments to the rebels from the United States.

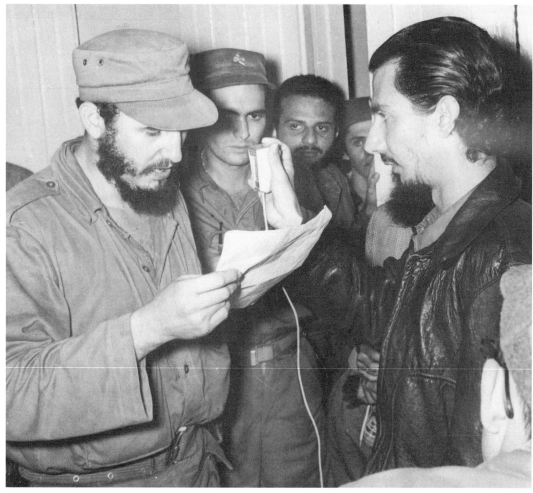

Jorge Enrique Mendoza, of Radio Rebelde and later of the newspaper *Granma*, with Castro.

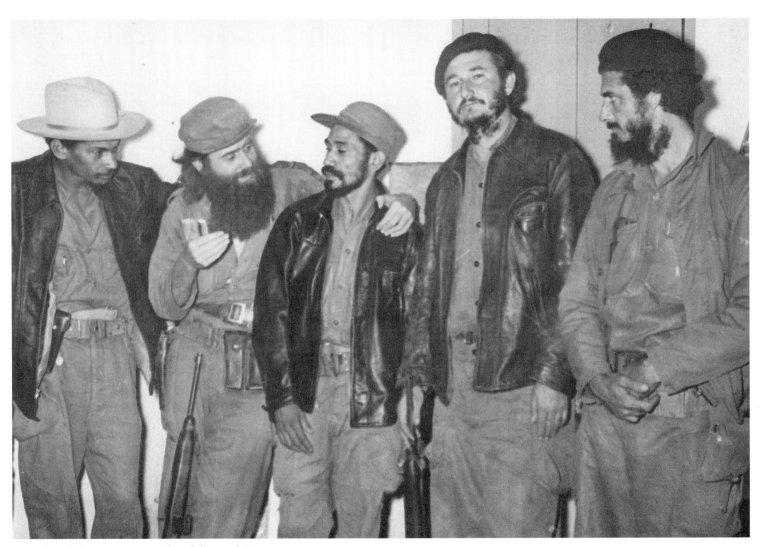

Juan Almeida (*center*), commander of the revolution,
relaxes with friends during the celebrations.

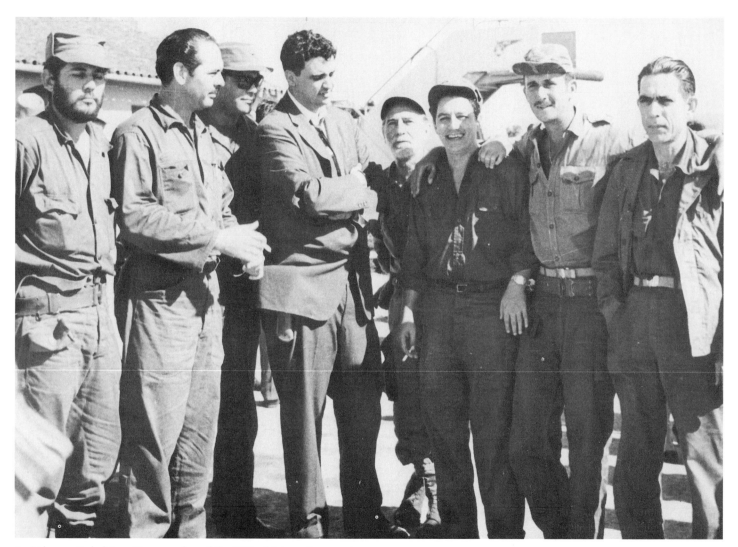

José Llanuza Gobel (in suit), a member of the 26th of July underground
and a community leader, greets the rebels at the Santiago de Cuba airport.

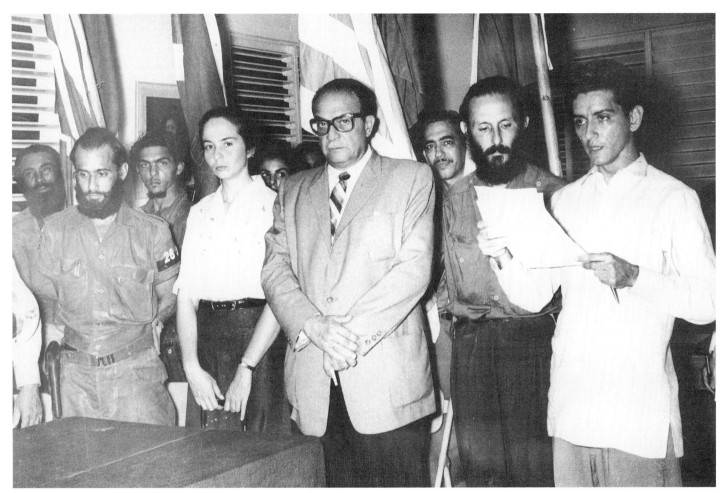

Euclides Vázquez Candela reads from a prepared statement accepting the surrender of Batista's forces to the rebels. Carlos Franqui (director of Radio Rebelde), José Miró Cárdona (*in center, with coat and tie*), who became the first prime minister of the new government, and Vilma Espín look on.

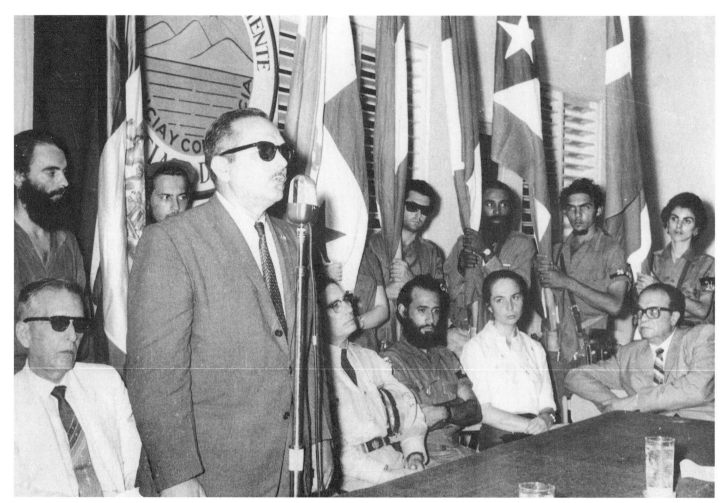

Vilma Espín (*sitting*) represented the revolutionary forces during the official surrender in Santiago de Cuba. Speaking to the delegation is Dr. Manuel Lleo Urrutia, a judge friendly to the rebels who became Cuba's president after the rebel victory. Urrutia was forced out by Castro several months later. Many of those pictured who represented the Batista government were later executed by firing squad.

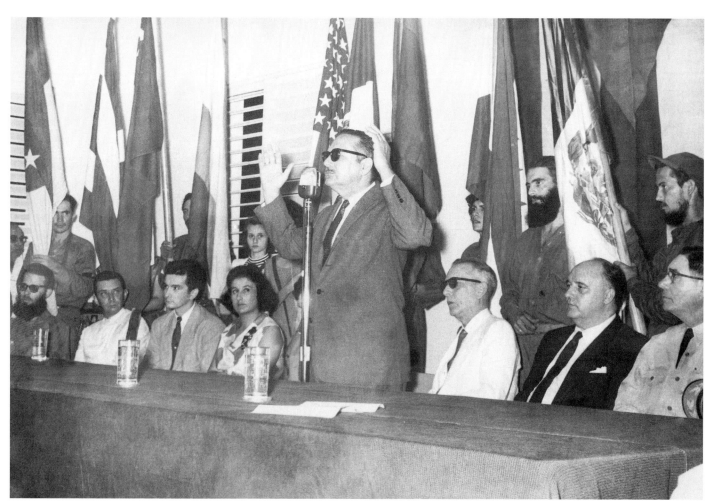

Judge Manuel Lleo Urrutia addressing the delegation during
the official surrender in Santiago de Cuba.

U.S. Ambassador to Cuba Earl T. Smith approves the change in power with friend and local businessman Felipe Valls at his side.

Col. Rego Rubido (*in uniform*) and other Batista representatives standing for the 26th of July anthem.

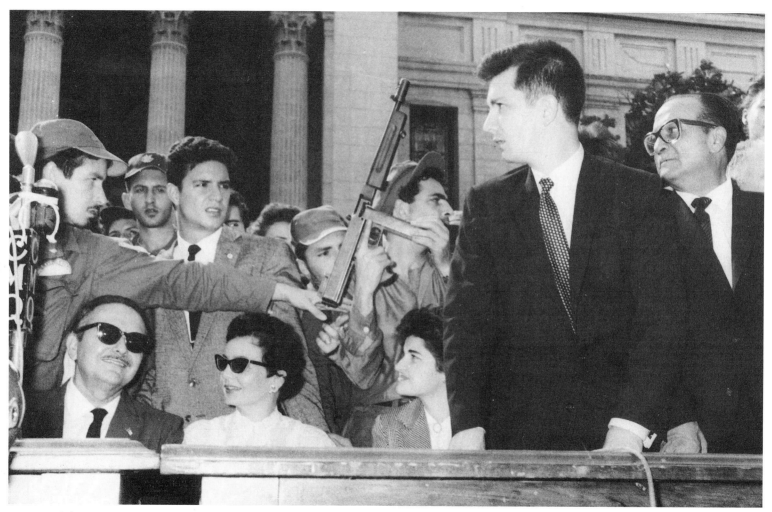

Dr. Manuel Lleo Urrutia (*sitting with dark glasses*) and other officials
from Santiago de Cuba waiting to address the public.

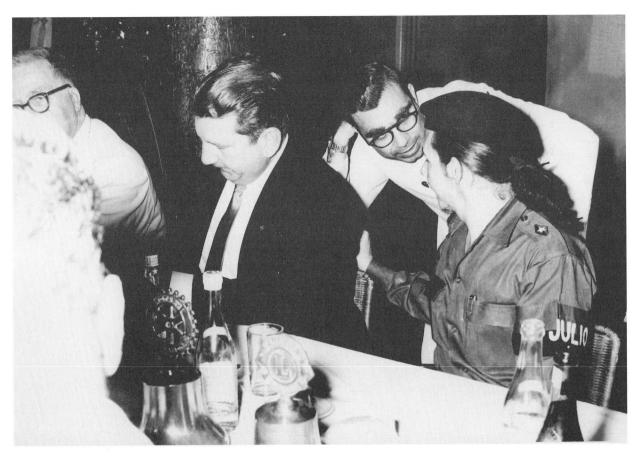

Commander Raúl Castro and Eloy Gutierrez Menoyo (*center*)
are greeted by Father Jorge Bez Chabebe of the La Salle
Catholic prep school at a Rotary Club meeting.

Facing page: From left to right: Commander Belarmino "Anibal" Castilla,
Commander Villa Montseny, Commander Manuel "Barba Roja" Piñeiro,
Commander Nicaragua Iglesias, and Commander Díaz Lanz. Standing
behind them is commentator Carlos Estrada from La Fabulosa radio station.

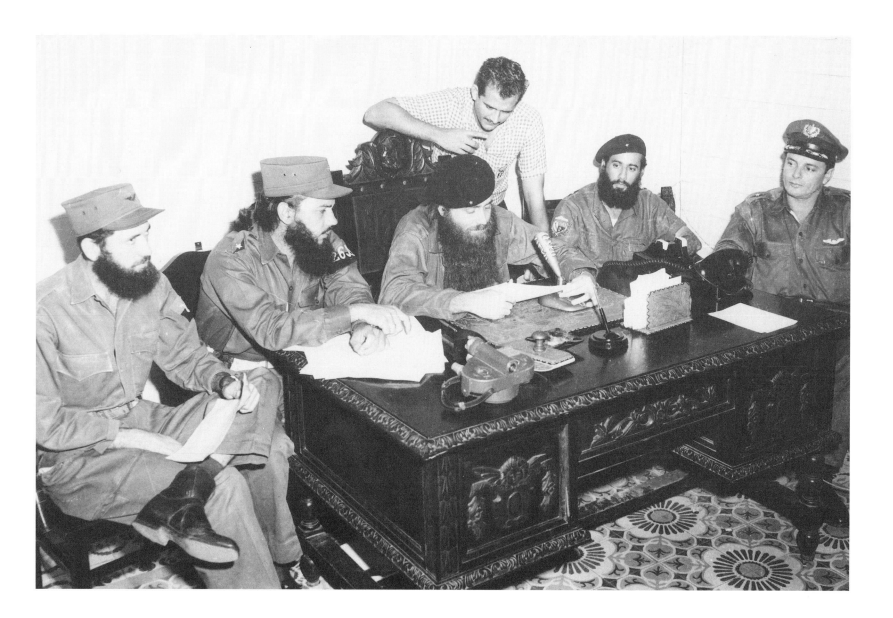

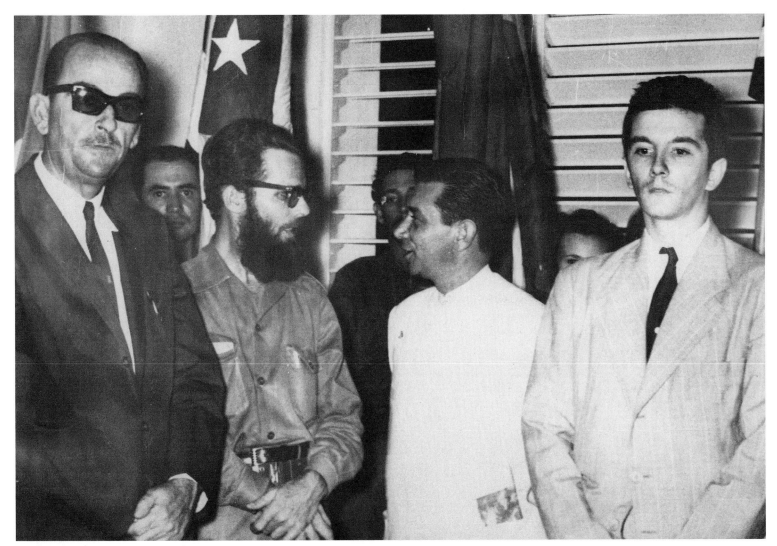

Armando E. Hart (*far right*), leader of the underground movement in Havana, attends the ceremonies with coleaders Faustino Pérez (*center*) and Ángel Fernández (*far left*).

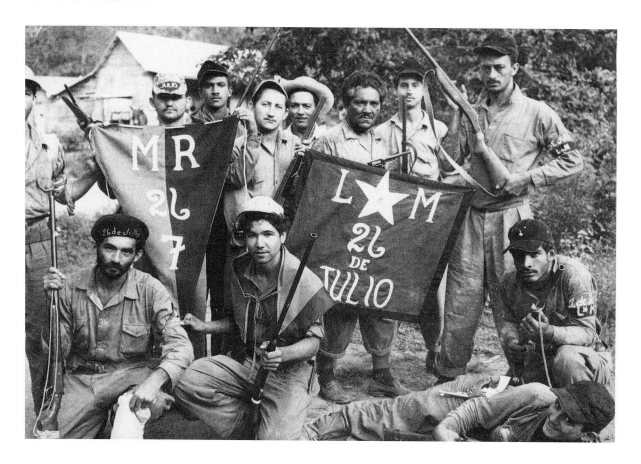

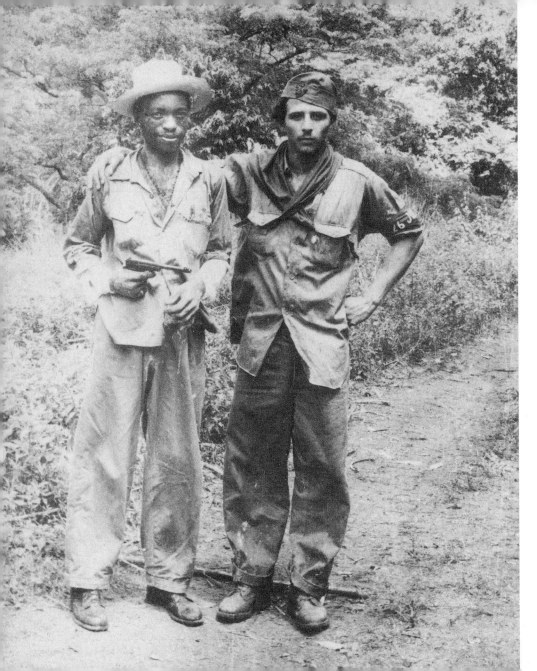

University Press of Florida

GAINESVILLE · TALLAHASSEE · TAMPA · BOCA RATON

PENSACOLA · ORLANDO · MIAMI · JACKSONVILLE · FT. MYERS

The Cuban Revolution

Years of Promise

Teo A. Babún and Victor Andrés Triay

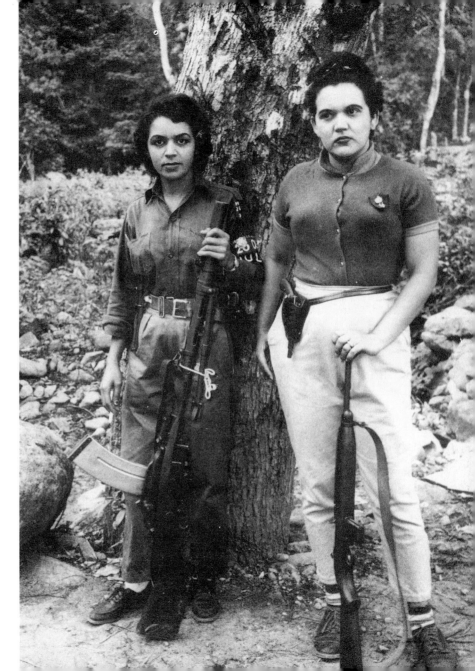

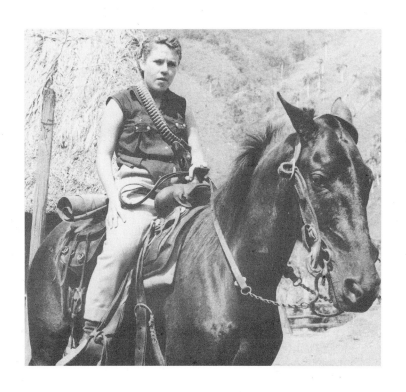

10 09 08 07 06 05 6 5 4 3 2 1

Babún, Teo A.
The Cuban Revolution: years of promise / Teo A. Babún and Victor Andrés Triay.
p. cm.
ISBN 0-8130-2860-4 (alk. paper)
1. Cuba–History–1933–1959–Pictorial works. 2. Cuba–History–Revolution,
1959–Pictorial works. 3. Cuba–History–1959–Pictorial works. 4. Cuba–History–
1933–1959. 5. Cuba–History–1959–. I. Triay, Victor Andrés, 1966–. II. Title.
F1787.5.B23 2005
972.9106'3–dc22 2005048560

The University Press of Florida is the scholarly publishing agency for the State
University System of Florida, comprising Florida A&M University, Florida Atlantic
University, Florida Gulf Coast University, Florida International University, Florida
State University, University of Central Florida, University of Florida, University of
North Florida, University of South Florida, and University of West Florida.

University Press of Florida
15 Northwest 15th Street
Gainesville, FL 32611-2079
http://www.upf.com

Cuba is an independent and sovereign State organized as a unitary and democratic Republic for the enjoyment of political freedom, social justice, individual and collective welfare, and human solidarity.

TITLE I, ARTICLE I, 1940 CUBAN CONSTITUTION

Contents

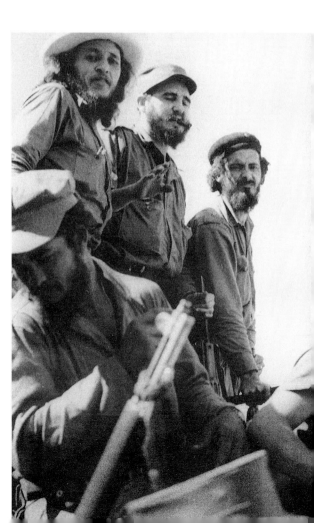

On May 28, 1957, almost six months after his landing in southeastern Cuba, Fidel Castro led his small guerrilla band in an attack against a Cuban army garrison situated within the compound of my father's sawmill of El Uvero, near the town of the same name. The tiny battle of El Uvero, the first significant victory for Castro's guerrillas over the forces of dictator Fulgencio Batista, came on the heels of failed uprisings against the government and helped energize the movement to reestablish democracy in Cuba.

My father, Teofilo "Tofi" Babún, an influential industrialist from nearby Santiago de Cuba, sensed that the events of May 28 marked the beginning of an important period in Cuba's history. He developed a close rapport with the Castro rebels and used his business as a cover to smuggle arms, ammunition, and radio equipment to them. In return, his photographer, José "Chilin" Trutie, was granted special access to the rebels and permission to snap pictures of what he saw. Little did my father know that a few years later a son, three nephews, and a brother-in-law would be landing at the Bay of Pigs in an attempt to overthrow Castro—once again, in the name of Cuban democracy.

Following my father's death in 1987, I found two shoe boxes filled with photographs he had collected of this period, including many of those taken by Trutie. After years of organizing the photographs and identifying faces, I decided to tell the story of the Cuban Revolution and its immediate aftermath through my father's collection. In 2003, I joined forces with Cuban-American historian Victor Andrés Triay to bring this book to fruition. I am sure my father, who died before he could return to a free Cuba, would have been tremendously pleased with the outcome.

Teo A. Babún Jr.
Miami, Florida

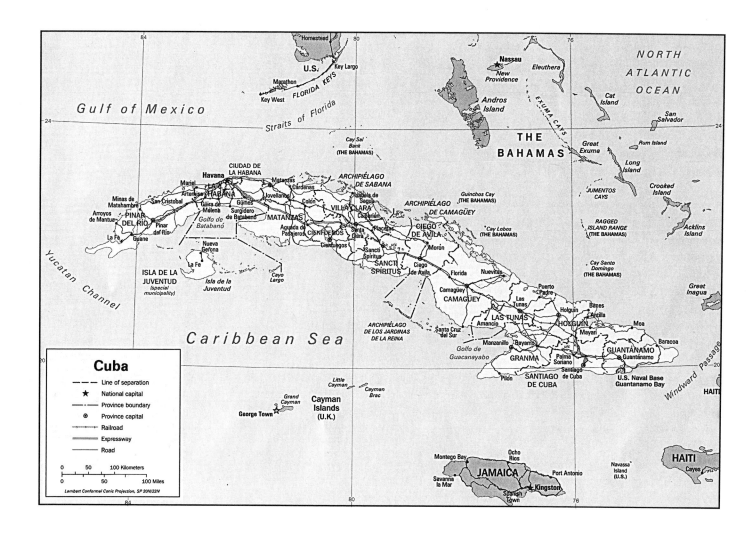

A Photographic History of the Cuban Revolution

This is a photographic history of some of the people and events of the Cuban Revolution and its immediate aftermath. The book captures the adventure, hope, and disappointment of this momentous period in world history.

In 1952 the people of Cuba, furious over a decade of political gangsterism and public corruption, prepared for a national election. Less than three months before election day, however, Fulgencio Batista, a career military man and former president who was running a distant third in the presidential contest, launched a bloodless coup d'état with the support of army officers. He installed himself as president, vowed to end corruption in Cuban politics, and promised to hold elections as soon as possible under the guidelines of Cuba's popular 1940 Constitution, one of the most progressive in Latin America.

Among the candidates for the House of Representatives in the aborted 1952 election was Fidel Castro Ruz. Born in Cuba's easternmost province of Oriente to a Spanish immigrant father who had prospered on the island, Castro was educated in Catholic preparatory schools in Santiago de Cuba (Oriente's capital) and Havana. He entered the University of Havana in 1945 and became associated with the Unión Insurreccional Revolucionaria, one of the university's most notorious gangster political groups.[1] As a student, Castro was considered power hungry and unprincipled, and never achieved high office in university politics.[2] He was, nevertheless, linked to a number of assassinations and other sensational acts of political violence, including a failed invasion of the Dominican Republic in 1947 and the 1948 Bogotazo riots in Bogotá, Colombia, which claimed the lives of three thousand people.[3]

By the time Castro finished law school he was a member of Eduardo Chibás's Ortodoxo Party. Chibás, who before his 1951 suicide brought the crusade against corruption in Cuba to a fever pitch, reportedly considered Castro to be an untrustworthy gangster despite the latter's party activism.[4] In any event, Batista's 1952 coup ended Castro's career as an elected politician even before it started and opened the door for him to take an approach better suited to his personality.

On July 26, 1953, Castro and a group of followers entered Santiago de Cuba and launched a quixotic attack against the Cuban army's Moncada barracks and

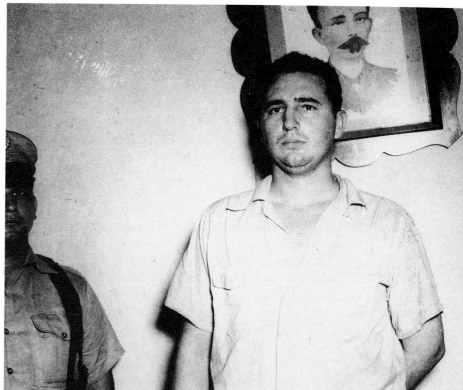

A young Fidel Castro Ruz awaiting trial for his 1953 attack on the Moncada military barracks.

Crowd in front of the west entrance of the Moncada barracks after a failed attempt by Fidel Castro to incite a popular uprising on July 26, 1953.

other nearby targets. A second group attacked the garrison in the historic city of Bayamo. Intended to spark a national rebellion against Batista, the attacks of July 26 instead ended disastrously. Not only did they fail to rouse the public, but many of the attackers were captured, tortured, and shot. Castro and a few men from his group managed to escape into the nearby mountains, and their lives were ultimately spared thanks to the intervention of Santiago de Cuba's Roman Catholic archbishop, Enrique Pérez Serantes.[5]

During his October 1953 trial, Castro read from a manifesto he had penned entitled "History Will Absolve Me." In the document, he outlined his political program, citing the restoration of democracy as one of his primary goals.[6] Despite its failure, the bold and dangerous Moncada attack against Batista made Castro a national figure. Moreover, the intervention of a Catholic archbishop on his behalf, as well as his stated political agenda, gave him credibility with middle- and upper-class democrats and Catholics. In the end, Castro was sentenced to fifteen years in prison on the Isle of Pines.

Castro and his companions were released from prison in May 1955 after an amnesty was granted by President Batista, who had restored the 1940 Constitution the year before and subsequently rigged the 1954 election to give himself four more years in office. Castro received a hero's welcome from supporters in Havana, but decided to leave Cuba soon afterward to continue his struggle from abroad. Before departing for Mexico, where he would prepare his next move, he brought his followers together and created what became the 26th of July Movement (Movimiento 26 de Julio; named in commemoration of the Moncada attacks).[7] At around the same time, other groups also stepped up their efforts against the Batista government. The University Student Federation, angry over Batista's refusal to agree to new (and fair) elections in the "Civic Dialogue" he held with his democratic opponents, set up the clandestine Directorio Revolucionario to fight the government more directly and violently. Other groups, such as those associated with the former political parties, likewise escalated their efforts against the Batista regime.[8]

In Mexico, Fidel Castro and his brother Raúl organized the 26th of July's members and supporters abroad, which now included Ernesto "Che" Guevara,

the intensely anti-American Argentine physician and self-styled revolutionary who had served in Jacobo Arbenz's left-wing government in Guatemala.[9] The 26th of July members busied themselves in Mexico raising money, collecting arms, and training for an invasion of Cuba. Castro, while still proclaiming his adherence to the ideals of Eduardo Chibás, gradually separated his young movement from the Ortodoxo Party.[10]

Again overestimating the likelihood of a national rebellion, Castro launched a second major strike against the Batista government that ended nearly as disastrously as the first. In November 1956, eighty-one men under Castro's command departed from Tuxpan, Mexico, for their "invasion" of Cuba aboard the yacht *Granma*. Their landing at Oriente was timed for November 30, in conjunction with an uprising in nearby Santiago de Cuba led by Frank País, a local 26th of July rebel. The País-led rebellion was launched as planned and enjoyed success for two days. The Castro party, however, failed to land, and Batista quelled the País insurrection. On December 2, two days behind schedule, the Castro group finally landed in Cuba. In what was nearly a complete debacle, the *Granma* was spotted by a fighter plane, set upon by a naval frigate, and forced to land at Playa los Colorados, a swamp. The rebels abandoned most of their equipment, struggled to reach dry land, and desperately fled the army through nearby sugarcane fields. A number of them were captured or killed as they tried to reach the Sierra Maestra, and others escaped the region altogether. By the time the rebels regrouped in the mountains, fewer than fifteen remained.[11] Once again, the Cuban people did not rise to support Fidel Castro.

Back in Havana, Batista reacted to the violence in Oriente by rounding up suspected revolutionaries, instituting press censorship, suspending constitutional guarantees, and closing the University of Havana. Over the Christmas and New Year's holidays, as the remnants of Castro's rebels regrouped in the Sierra Maestra, 26th of July cells in the cities, using the terror tactics that had become so common in Cuban politics, set off bombs in public places (in many cases harming innocent civilians; see page 5).[12] Batista, responding with ferocity as well, rounded up and summarily killed suspected opposition activists. He did not, however, launch a major offensive against the Castro-led group

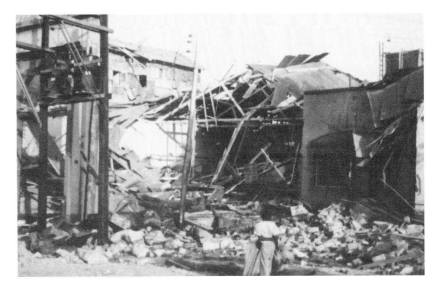

The destruction caused by a rebel-planted bomb at a sugar mill during the civil war.

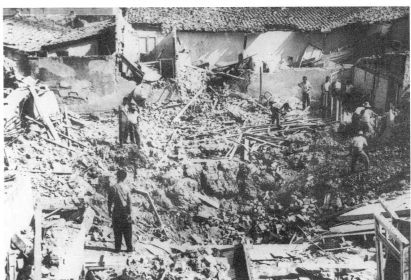

The aftermath of a rebel bombing, this one in the heart of Bayamo.

in the Sierra Maestra, apparently feeling the tiny rebel band would ultimately disintegrate in the harsh jungle terrain. Far from disappearing, the Castro rebels launched a successful surprise attack against the tiny La Plata garrison in mid-January 1957. Although little more than a skirmish, La Plata gave Castro's group a taste of victory and provided it with much-needed armaments. Over the next few weeks the rebels had some minor clashes with military patrols in the Sierra Maestra, but Batista continued to make very little effort to snare the minuscule rebel army, which numbered only eighteen men by mid-February.[13]

In early 1957, in what was perhaps the most fruitful move of his political career, Castro sought an interview with a foreign press correspondent. A few weeks later, his people smuggled the left-leaning veteran journalist Herbert Matthews of the *New York Times* into the Sierra Maestra. During the visit, the small group of rebels exaggerated the number of arms they possessed and made grossly fraudulent claims to Matthews about battles they had fought against Batista[14]—all of which the sympathetic reporter recorded as fact. Raúl Castro, in a move that must have seemed hilarious to his fellow rebels, paraded the same men in front of Matthews several times, leading him to believe the rebel army was much larger than it actually was.[15] When Matthews was preparing to leave, Fidel Castro told the reporter, "we have the whole area surrounded, and we will get you out safely."[16] As Georgie Anne Geyer aptly stated in her work, *Guerrilla Prince,* "Matthews thought he was in a jungle, and, in truth, he was: a jungle of obfuscation and deliberate deceit."[17]

The Matthews story, which received extensive publicity, was published in three articles, the first one appearing in the *Times* February 24, 1957, Sunday edition. Activists in Cuba smuggled copies into the island, and the Cuban press ran the full story in Spanish translation when Batista lifted press censorship shortly afterward. In the articles, first and foremost, Matthews confirmed that Fidel Castro was still alive (the government had given the impression that the rebel leader was dead).[18] More important, he painted Castro and his men as a heroic group of young, idealistic rebels who, against a vicious enemy, were winning a war to achieve the freedom of their country. The romantic image of Castro painted by the articles, reminiscent of the sensationalistic yellow journal-

ism that had characterized American newspapers during the Cuban War of Independence, catapulted the formerly obscure bearded rebel leader onto the international stage. "Just as the Hearst press helped to make the Cuban Revolution in 1898," wrote historian Paul Johnson, "so the *Times* sponsored Castro."[19] Without a doubt, the Matthews articles (and the reporter's implicit advocacy) gave Castro political traction at the most critical juncture of his career and did more to help his struggling movement than any other single event.

The Matthews articles and subsequent support from the *New York Times* led other media outlets, including American television, into the Sierra Maestra.[20] The coverage provided the world with a steady diet of Fidel Castro, who was always depicted romantically as a disinterested, selfless freedom fighter. The carefully crafted, media-inspired Castro myth became so instrumental in gathering political and financial support for the 26th of July Movement that Che Guevara later commented, "The presence of a foreign journalist, American for preference, was more important for us than a military victory.[21] The favorable publicity also captured the imagination of foreign intellectuals and university students, who became infatuated with the idea of a group of bearded, idealistic rebels fighting an evil dictator in a faraway and exotic land. Riding the wave of public excitement, local 26th of July organizations in the United States and Latin America succeeded in raising a great deal of money for the movement and gaining ready access to media outlets, which were often more than eager for news of the revolution.

Also in early 1957, Civic Resistance, an organization of middle- and upper-class Cubans eager to oust Batista and reestablish the 1940 Constitution, was formed. Although technically independent of the 26th of July Movement, Civic Resistance was, in fact, a front organization used to conduct propaganda and raise money for Castro in Cuba.[22] It eventually abandoned its policy of nonviolence and joined the underground war against Batista in Cuba's cities. Urban warriors of the Civic Resistance fought alongside the 26th of July's urban cells, the Directorio Revolucionario, associations connected to the democratic political parties, and a variety of smaller resistance groups.[23] The urban underground groups (mostly middle class in nature) engaged in propaganda, kidnapping,

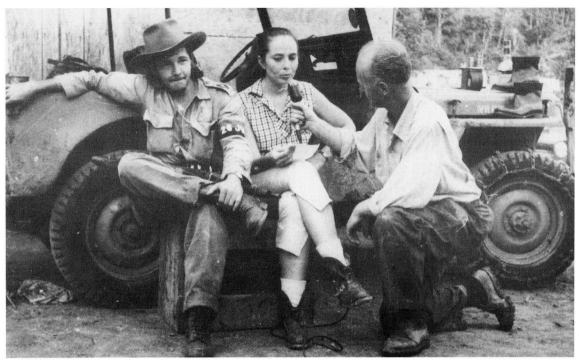

Raúl Castro and Vilma Espín talking to one of many journalists who visited the Sierra Maestra to report on the bearded rebels. One correspondent, Robert Taber of CBS News, ultimately gave up news reporting to become a leader in the Communist-leaning, pro-Castro "Fair Play for Cuba Committee" in the United States.

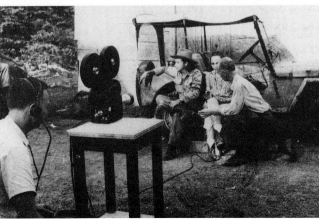

Raúl Castro and Vilma Espín talking to a journalist in the Sierra Maestra.

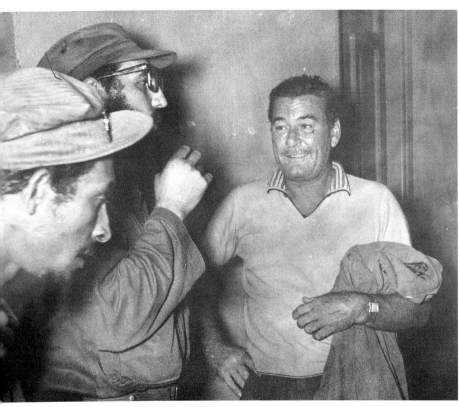

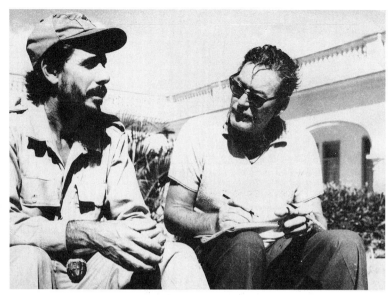

Errol Flynn takes notes for a movie project, *Rebel Girl*.

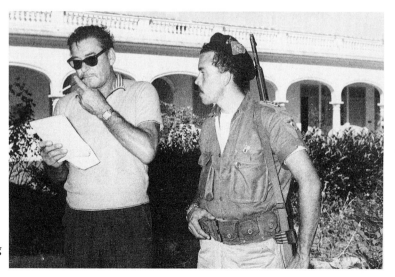

As Castro's war was sensationalized in the international press, a long succession of media luminaries visited the rebel army. Here, Fidel Castro discusses politics, ideology, and strategy with movie star Errol Flynn.

Rebel Captain Pepin López during an interview with Errol Flynn.

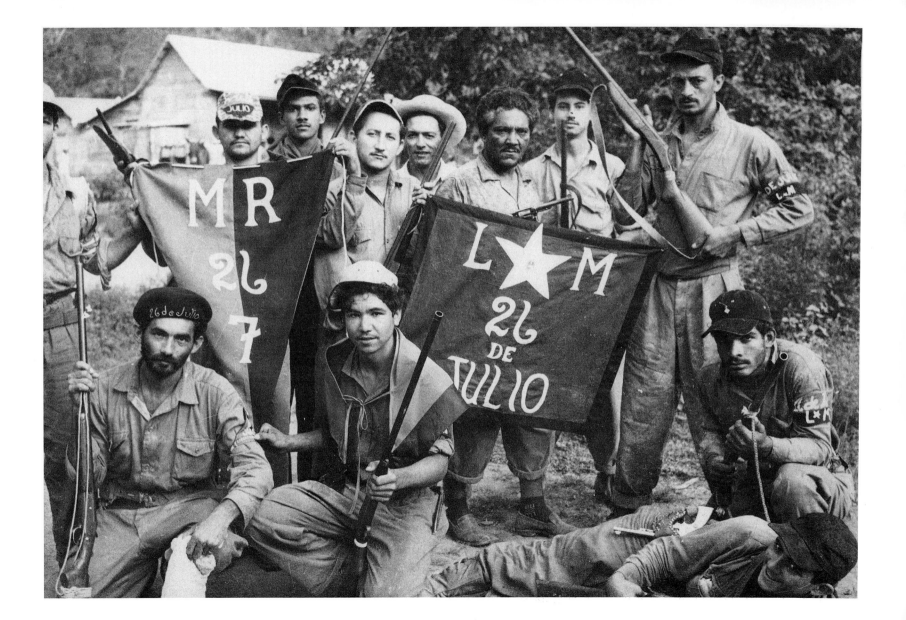

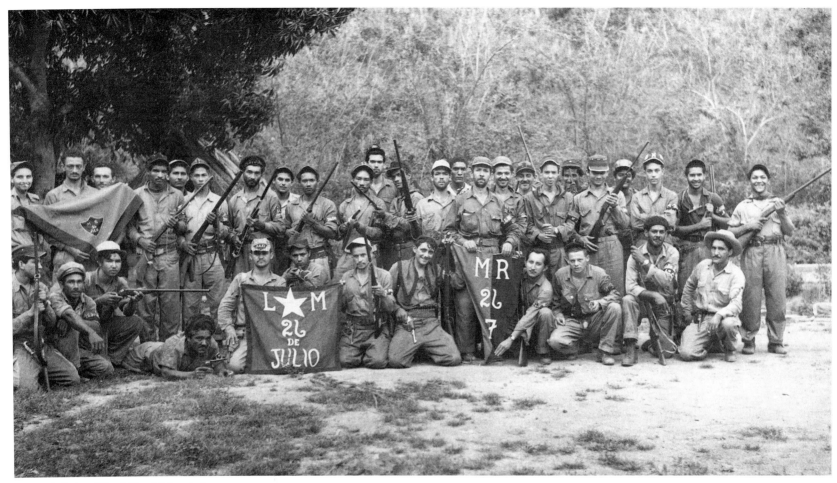

A posed photo of the 26th of July rebels.

Facing page: Many in the United States and around the world were infatuated with the idealistic 26th of July rebels.

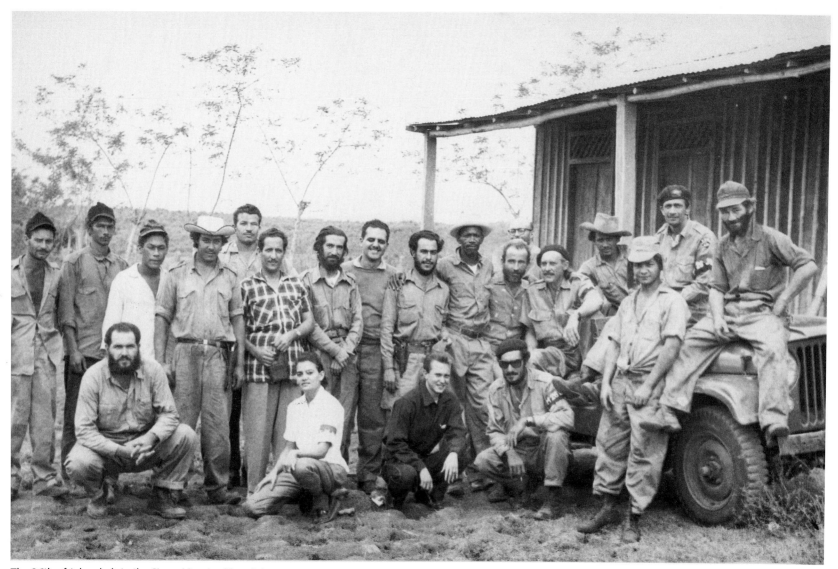

The 26th of July rebels in the Sierra Maestra Mountains.

bomb planting, and sabotage.[24] Because they confronted the Batista regime more directly, the urban fighters suffered a much higher death rate than the small group of mountain guerrillas who, paradoxically, received the lion's share of attention from the international press. As the most direct targets of the government's retaliatory strikes, members of the urban groups were frequently victims of torture and gangland-style murders by Batista forces. Noted Cuba scholar Jaime Suchlicki underscores the decisive role of the urban fighters in the anti-Batista struggle, stating, "It was the work of the urban underground more than anything else that brought about the downfall of the [Batista] regime."[25]

On March 13, 1957, a number of Directorio Revolucionario members (as well as members of the pro-democracy Auténtico Party) were killed when they tried to assassinate Batista in a brazen daytime attack on the Presidential Palace. Unaware that the palace attack had failed, José Echeverría, the head of the Directorio Revolucionario, was killed by police as he and a group of companions were en route to the university after leaving a popular radio station they had temporarily seized to announce Batista's death. The assassination attempt led to a wave of terror against Batista's enemies. Military death squads created fear among the youth in the cities, but popular opposition to the government grew as details of the Batista regime's grotesque assassination strategy came to light.

Echeverría's death weakened the Directorio Revolucionario and left the 26th of July Movement the strongest insurrectionist group on the island. Young Cubans who wanted to take direct action against the Batista government, or who were just seeking romance and adventure, became increasingly attracted to Castro's movement. In May 1957, Castro's mountain-based rebel army, its ranks now swelled to around 130, launched a well-planned attack against the small coastal army post of El Uvero on Babún family property. In the space of a few hours, the rebels overwhelmed the post and melted back into the mountains, taking with them all the supplies they could load aboard one of the Babún family trucks.[26] This small battle, the first significant victory for the rebel army, provided an important morale boost to the mountain fighters and energized anti-Batista forces across Cuba.[27]

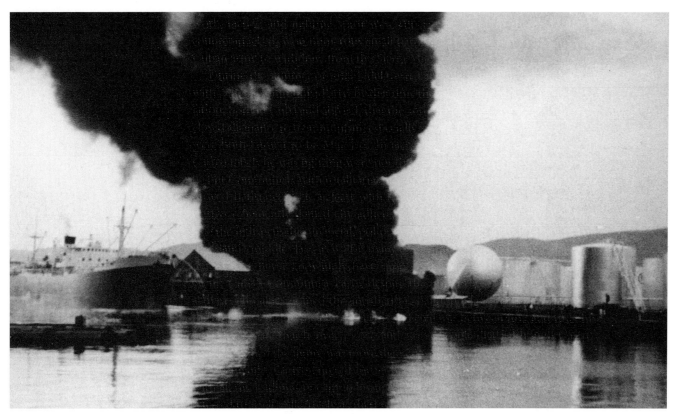

Fires, set by anti-Batista rebels as part of
their sabotage campaign, raged from one
end of the island to the other, killing many.

Facing page, top: During the last three months
of 1958, the rebels severely disrupted transpor-
tation between Havana and the three eastern
provinces.

Facing page, bottom: A train captured by rebel
forces in Oriente province.

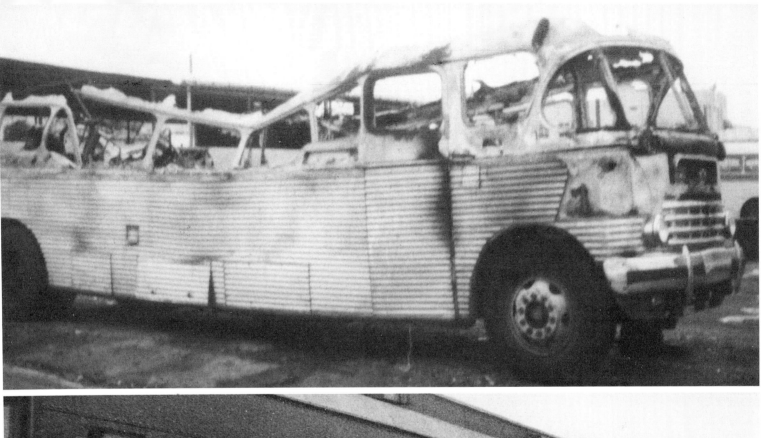

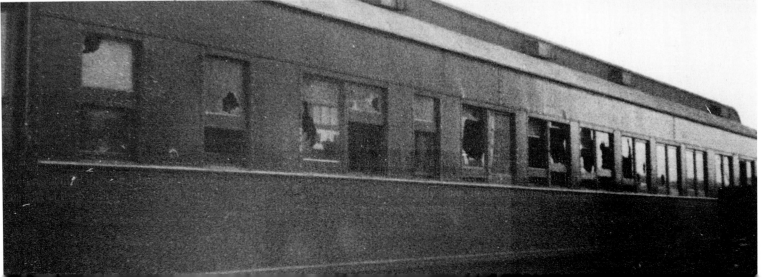

Rural as well as urban groups
committed acts of sabotage.

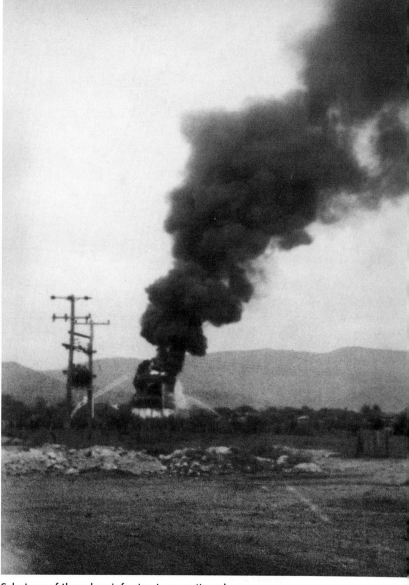

Sabotage of the urban infrastructure continued.

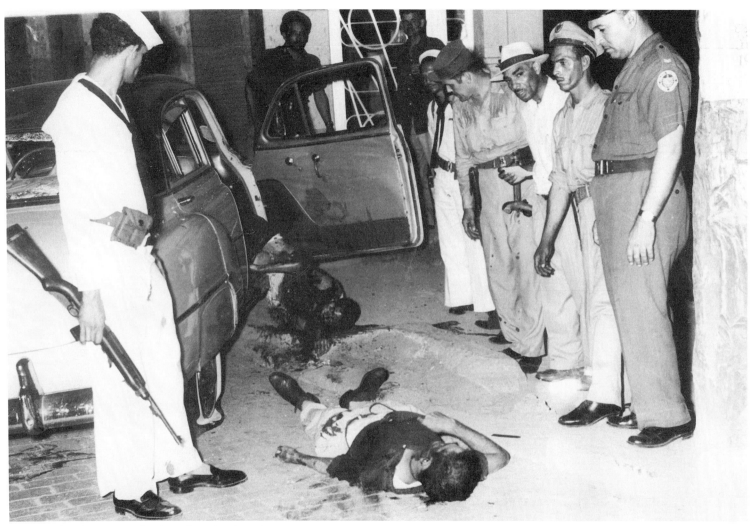

Floro Vistel and Josué País (brother of Frank País and co-leader of the local 26th of July cell) were assassinated while driving in the streets of Santiago de Cuba.

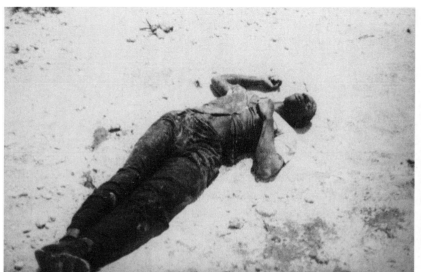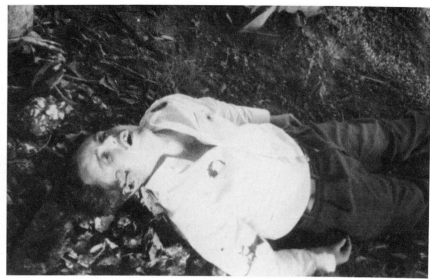

As the revolution gained momentum, murders of suspected rebels or rebel sympathizers increased.

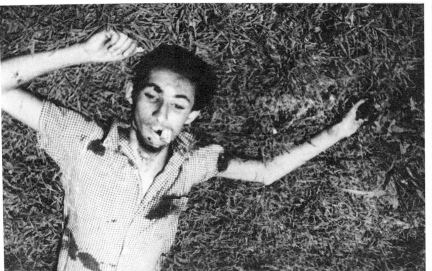

It was common for the bodies
of young men shot to death to
be found alongside a road.

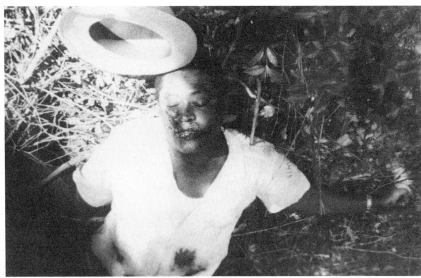

A man murdered as an
alleged Castro supporter.

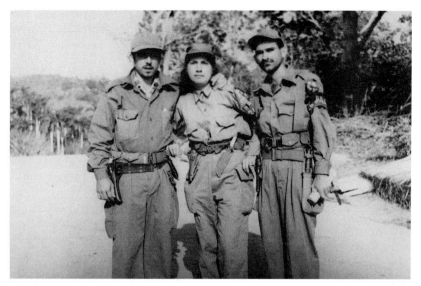

Many signed up to be part of the effort
to overthrow Batista.

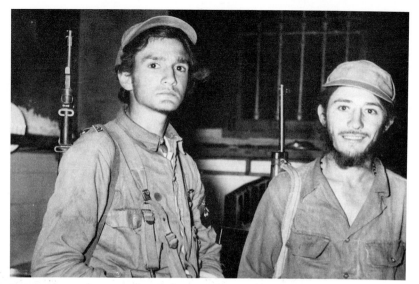

Teenaged guerrillas ready for action.

People from all sectors of
Cuban society, including these
young peasants, joined the
small guerrilla army.

By the summer of 1957, Castro's rebel force had grown to two hundred men and women and commanded many parts of the Sierra Maestra.[28] Fidel Castro's apparent goal now was to stay alive in the mountains of Oriente and to remain the national (and international) symbol of the anti-Batista struggle. Accordingly, Castro deliberately kept the rebel army out of the enemy's reach and engaged in only low-risk attacks (and sabotage) whereby it could gain publicity, rattle Batista's forces, or steal weapons. With the 26th of July's propaganda machine effectively perpetuating the romantic Castro myth in Cuba and abroad, and the much larger urban forces doing the brunt of the fighting and dying, Castro hoped that the lazy and corrupt forces propping up Batista would become frustrated and demoralized and ultimately implode. He could then sweep in to fill the void. This strategy, largely psychological, proved enormously successful. Batista, perhaps unwittingly, also contributed to its success by waiting too long to use all the military power at his disposal to hunt Castro down.

By early 1958 Fidel Castro began to act as the de facto ruler over the parts of the Sierra Maestra he occupied, referring to it as Cuba's Territorio Libre (Free Territory). The mountain guerrilla world by then included a repair shop, an armory, a hospital, a shoe factory, bread ovens, and a lecture hall.[29] In February, the rebels even established their own mountain-based radio station, Radio Rebelde, to communicate directly with the Cuban people. (The modern radio transmitter was provided and smuggled into the Sierra Maestra for the rebels by the Babúns.) The broadcasts began defiantly, "Here, Radio Rebelde, transmitting from the Sierra Maestra in Cuba's Free Territory."[30] Many locals, especially peasants who had been mistreated by the Rural Guard, grew to sympathize with the rebel cause. Others cooperated with them out of concern for their own well-being. Peasants suspected of being informers and rebels believed to be traitors were brutally executed on Fidel Castro's orders.[31]

Also in 1958, opposition groups in Cuba launched a campaign to pressure the U.S. government to stop arms shipments to Batista. Powerful individuals in the U.S. State Department sympathetic to the cause managed to have an arms embargo enacted in March. The U.S. government then ordered Batista to withdraw from combat all the weapons his government had received through the

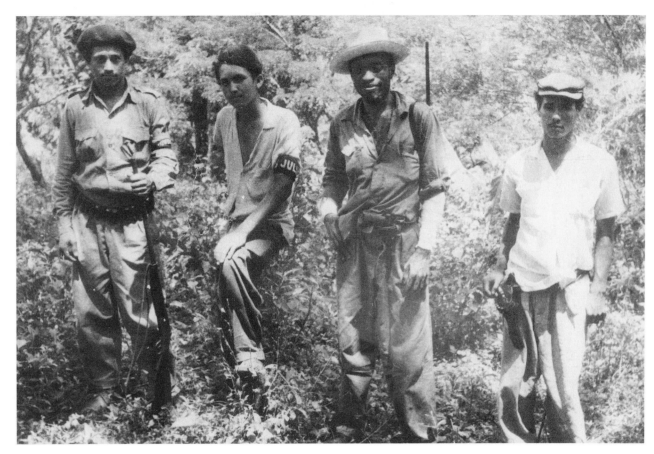

Opposition to Batista cut across racial lines.

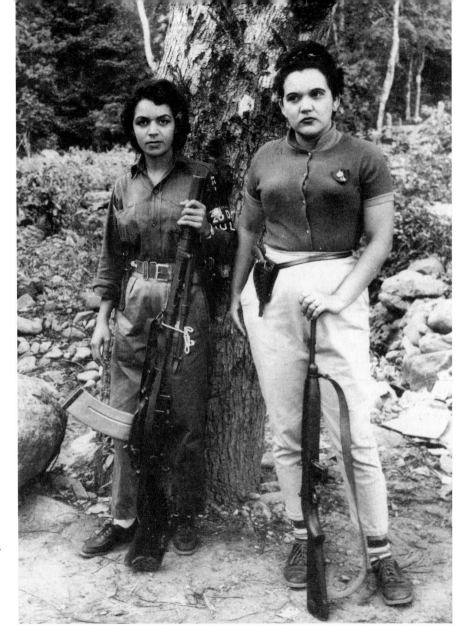

Rebel Lidia Doce (*right*) and a friend showing off their captured weapons. Doce died fighting Batista forces a few days after this photograph was taken.

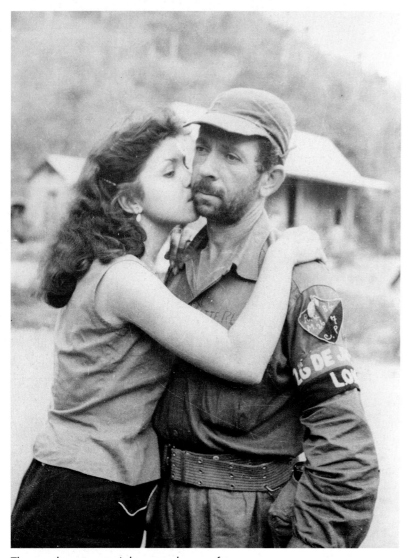

The popular movement drew people away from their loved ones.

A new recruit could easily drive a few miles out of Santiago de Cuba in the afternoon, and by the next morning be wearing a 26th of July uniform.

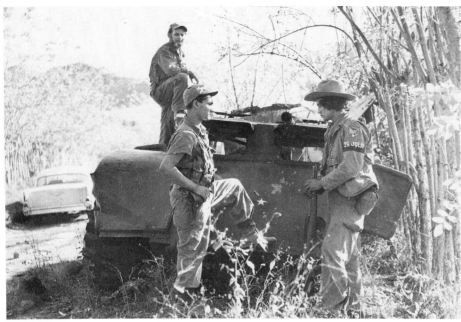

The Dragon I was a makeshift tank made from a tractor with steel plates welded to it. Forces under the command of Camilo Cienfuegos used it with great effectiveness.

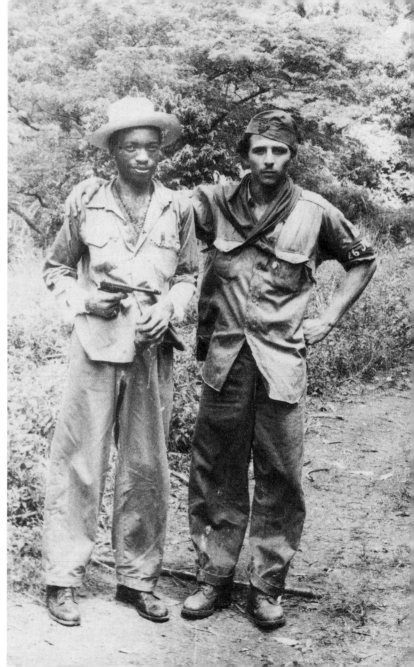

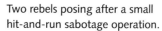

Two rebels posing after a small hit-and-run sabotage operation.

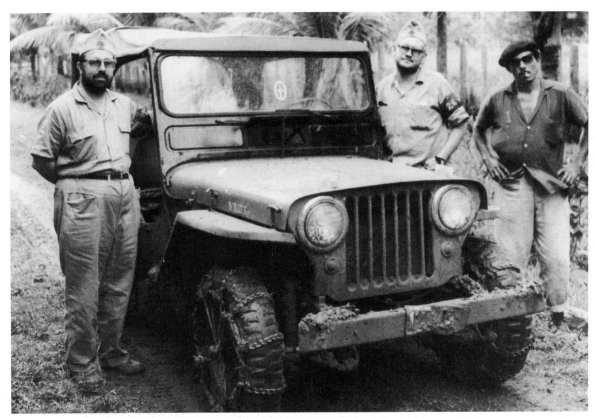

The rebel army had both Catholic and Protestant chaplains. Many of Cuba's Catholic lay organizations were active against Batista. Here, Catholic priests pose with their Jeep in the Sierra Maestra. Once in power, Castro launched an antireligious campaign and expelled a large number of Cuba's clergy.

Facing page: On weekends, family and friends would drive out to meet their loved ones fighting with the guerrillas, bringing food, religious items such as rosaries and scapulars, and good-luck charms.

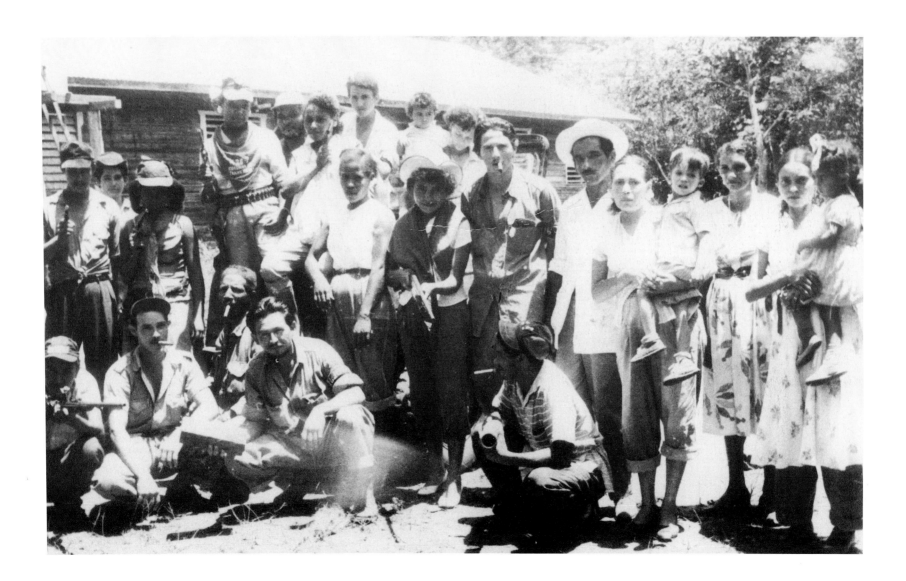

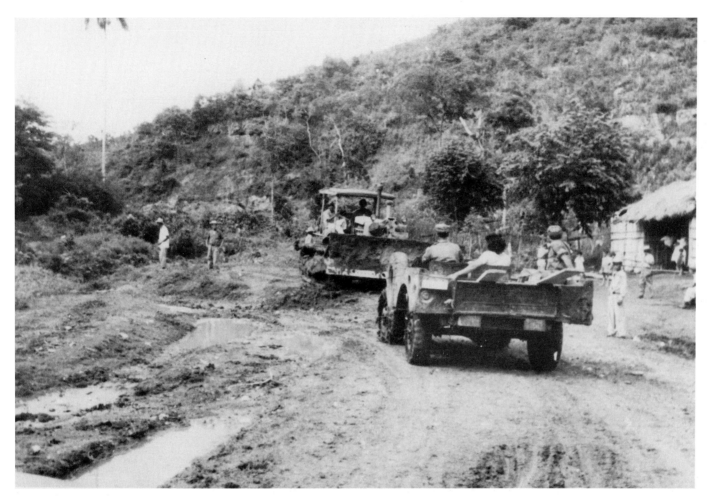

Getting from one place to
another in the rough terrain
necessitated heavy vehicles.

Military Defense Assistance Program, which was intended to arm Latin American nations for hemispheric defense.[32] The Cuban army and police, already weary from battling the opposition, now believed the United States had abandoned Batista and had indirectly transferred its support to the rebels. As a result, their morale and willingness to fight plummeted, beginning the implosion Castro sought. In addition to the arms embargo, the State Department asked the Immigration and Naturalization Service not to pursue Castro supporters in the United States who were sending money and arms to the rebels in violation of the neutrality laws.[33] Appreciating the significance of these developments, Castro declared "total war" on Batista and called for a national strike on April 9, 1958.

The strike of April 9 was a complete failure, as only a small handful of workers heeded Castro's call. Furthermore, Batista's forces killed a number of urban underground fighters and put many of their bodies on public display. Castro quickly recovered from this blow and, instead of backing down, consolidated his leadership and escalated the guerrilla war. His brother, Raúl, had earlier been sent into the Sierra Cristal of eastern Oriente to establish the 26th of July's authority over independent anti-Batista guerrillas there. During the summer of 1958, Raúl carried out spectacular kidnappings of Americans and Canadians, hoping his actions would pressure the United States, among other things, to stop providing fuel for enemy planes. Although the United States refused to be blackmailed and made no concessions, the sheer audacity of the actions brought Raúl Castro and the 26th of July a great deal of publicity. A capable guerrilla fighter Raúl Castro and his men encountered the regular army 247 times, captured six airplanes, intercepted five ships, and shot down three air force planes throughout the civil war.

Batista launched his only major offensive against Castro in May 1958, when he sent a large force into the Sierra Maestra to destroy the little rebel army—which still contained only around three hundred men. Although the offensive succeeded in squeezing the rebels into four square miles of territory, Batista's forces, unaccustomed to the terrain, became exhausted and their already low morale collapsed.[34] The 26th of July mountain rebels, whose intelligence net-

work, tactics, and fighting spirit were superior to those of their adversaries, counterattacked, won numerous small battles, and within a month forced the Cuban army to withdraw from the Sierra Maestra.

During the summer of 1958, Fidel Castro also made his first official contacts with Cuba's Communist Party. By that time there had already been heavy speculation, both in Cuba and abroad, that the 26th of July Movement had an undisclosed allegiance to Communism, especially since Che Guevara and Raúl Castro were both known to be Marxists. In fact, Batista frequently claimed that the Castro rebels he was fighting were not the liberal democrats they purported to be but Communists with totalitarian designs for Cuba. Although future events proved Batista correct, at least with regard to the 26th of July's inner circle, Castro vehemently denied any adherence to Communism (he didn't want to lose the indispensable financial, political, organizational, and moral support of the island's middle class, as well as many of the movement's own guerrillas, who would have never knowingly have supported a Communist cause).[35] In any event, Cuba's Communist Party, despite the objections of many 26th of July activists and allies, joined the anti-Batista coalition in 1958 and participated in the fighting. During the political crisis and civil war between 1952 and 1958, historians estimate that between 1,500 and 2,000 people died, although Castro's people claimed the figure was more than 20,000.

Meanwhile, Castro entered into a pact in Caracas, Venezuela, in July 1958 with all the leading opposition groups, except the Communists. The coalition referred to itself collectively as the Frente Cívico Revolucionario Democrático and promised to bring about Batista's downfall and the restoration of democracy in Cuba. The group chose well-known liberal lawyer José Miró Cardona as its coordinator, Fidel Castro as commander-in-chief of its armed forces, and Judge Manuel Lleó Urrutia as the president of Cuba in arms.[36] Being surrounded by such noted pro-democracy figures surely bolstered Castro's assertions of commitment to the constitution and democratic elections.

In August 1958, with Batista's forces substantially softened by low morale and a general reluctance to continue the fight, Fidel Castro finally went on the offensive. His troops began to encircle Santiago de Cuba, while a force under Che

Raúl Castro Ruz. Ultimately, Castro became first vice-president of the Council of State, first vice-president of the Council of Ministers, a four-star general, and minister of the Revolutionary Armed Forces.

A capable guerrilla commander, Raúl Castro Ruz was one of the traditional Marxists in the 26th of July Movement. His sadistic tendencies emerged in the wake of victory when, under his orders, more than a hundred Batista supporters were shot into a mass grave.

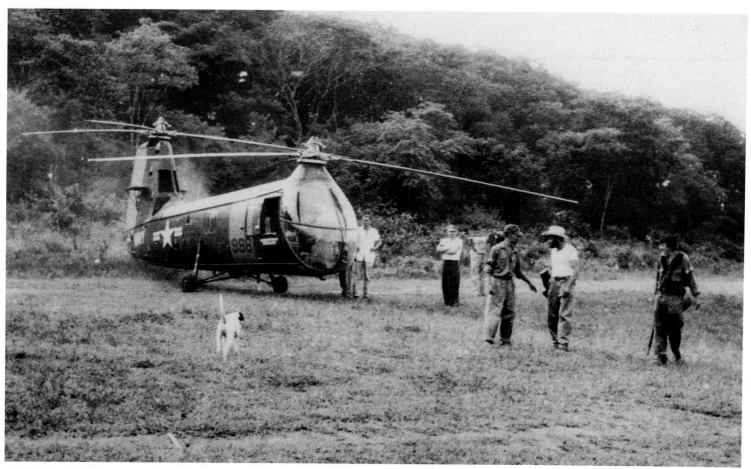

Raúl Castro's kidnapping of foreigners boosted the image of the rebel army. U.S. helicopters were used to ferry hostages and negotiators in and out of the hills.

Facing page: Raúl Castro's Second Front became known for its guerrilla tactics. Here the group poses; the man at bottom left holds a *boqui toqui* (walkie-talkie).

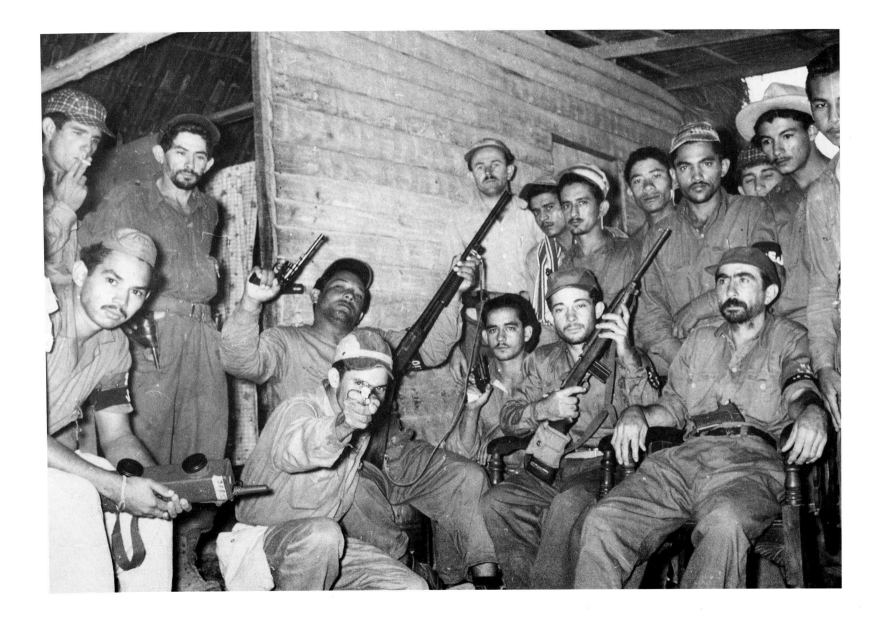

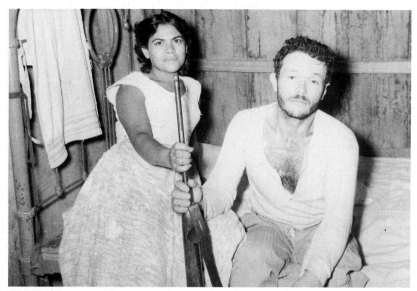

Besides the perils of war, natural perils, such as malaria, took their toll. This man in sick bay waits for a diagnosis.

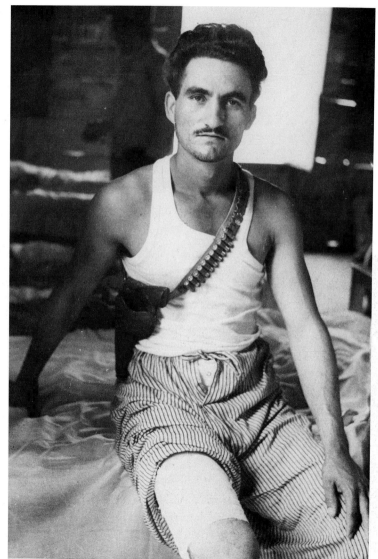

An injured fighter in the Sierra Maestra.

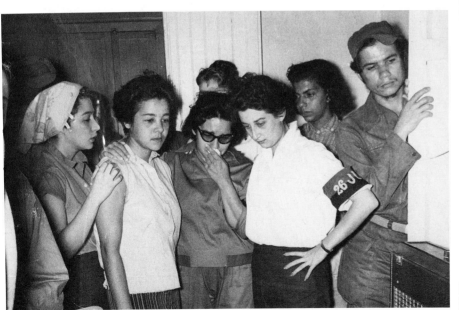

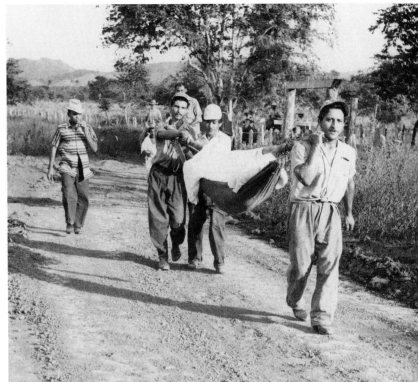

A body being taken for burial.

For the rebels, victory had a
high human cost.

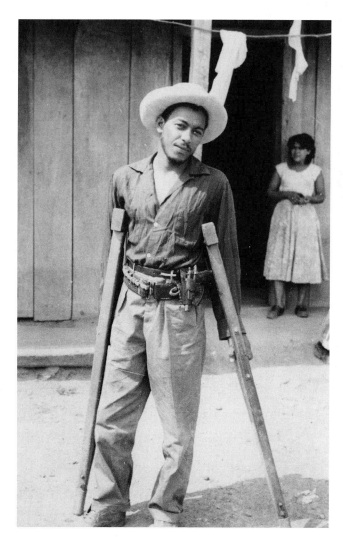

An injured rebel.

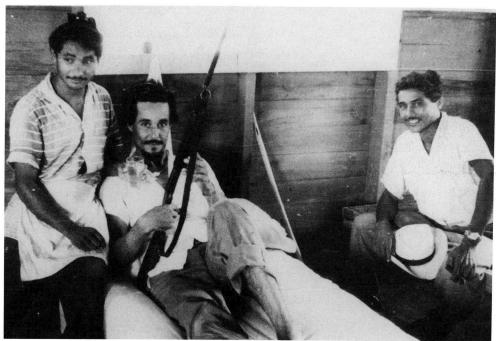

A wounded rebel in the field hospital near El Caney.

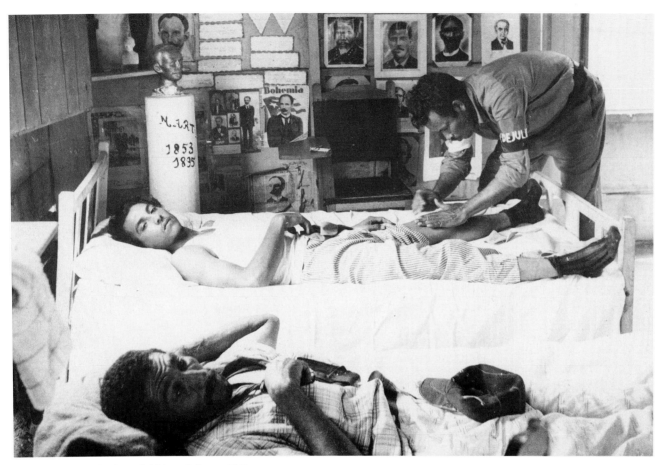

The busy field hospital near El Caney.

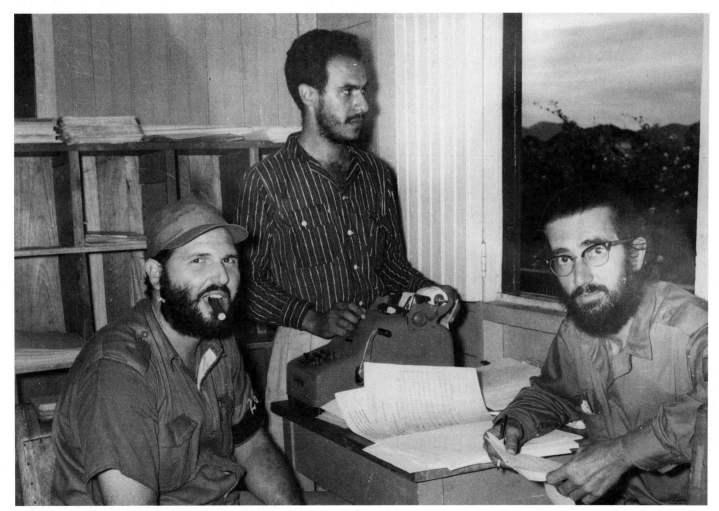

From left to right: Jorge Gomez, Adolfo Arrazola, and
Lt. René León, in charge of the rebel forces' payroll.
Gomez and Arrazola ultimately became disillusioned with
Castro after his rise to power and went into exile.

Guevara and Camilo Cienfuegos deployed west into Las Villas province to cut all communication between the two ends of the island. Guevara was also sent to establish the 26th of July's authority over the guerrilla army in the Sierra Escambray, which was made up of members of the Directorio Revolucionario and other coalition groups. Castro's forces tightened the noose throughout the fall as the November elections approached. Castro, not wanting an election to impede his road to power, called for the assassination of all the candidates and warned that anyone who tried to vote would be gunned down at the polling places.[37] The candidate from Batista's party, Andrés Rivero Agüero, predictably won the rigged election and was supposed to take office in February 1959. (Batista could not succeed himself according to the 1940 Constitution.) The public outrage over the sham election was considerable, increasing popular support for the revolution.

Batista's final collapse came in December 1958, before Rivero Agüero could even take office. In Las Villas, the forces under Cienfuegos and Guevara destroyed bridges and rail lines, and began to take over numerous towns. The Tercer Frente Oriental, headed by Castro subordinate Juan Almeida Bosque, encircled Guantánamo, and several officers of the Cuban army defected to Castro near Santiago de Cuba. With Batista's fall now only a matter of time, the ranks of the rebel army swelled to three thousand in December—ten times the size it had been earlier that year (several rebel leaders are shown in the photos on pages 44–54).[38] Government forces, completely demoralized and plagued by defeatism, were surrendering to far inferior rebel forces en masse after scarcely an exchange of gunfire. Having already lost the support of the United States and most of the Cuban public, Batista tried to make one last stand at Santa Clara, the capital of Las Villas. At Santa Clara, Che Guevara attacked an armored train that acted as the army's key command post and later derailed it with tractors from the local university's School of Agronomy. The Civic Resistance cells in Santa Clara attacked police, and by the last day of 1958 half the city was taken.

With Santa Clara on the verge of falling into rebel hands, Batista ordered some of his top commanders to a New Year's Eve celebration in Havana. At the party, he announced his resignation and later boarded an airplane for the Do

Guevara's forces succeeded in
cutting communication between
the two ends of the island.

A crew apparently
cataloguing the casualties.

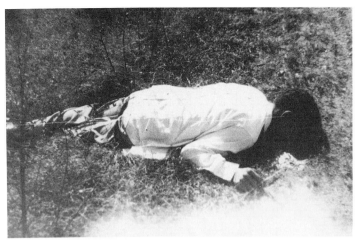

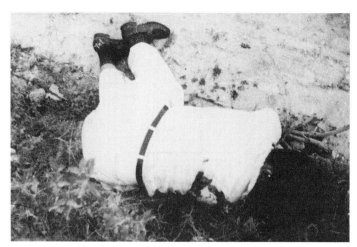

Nameless casualties of the civil war.

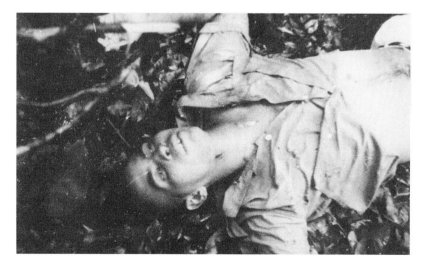

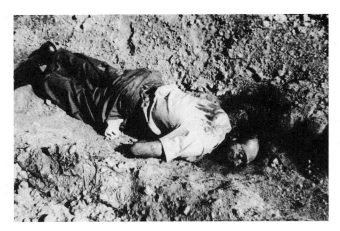

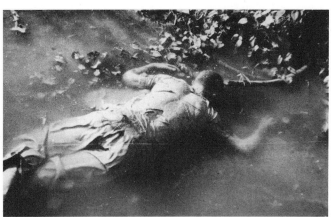

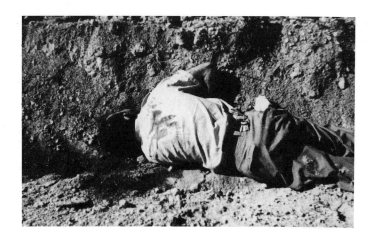

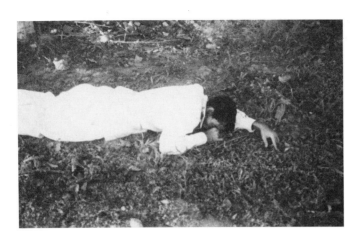
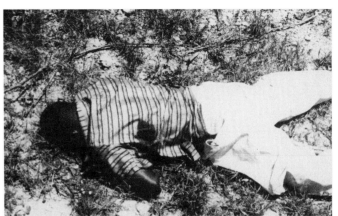
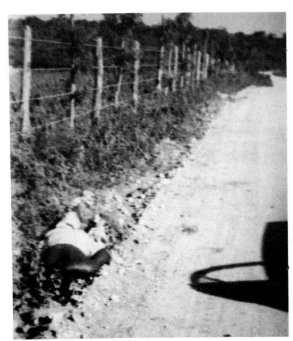

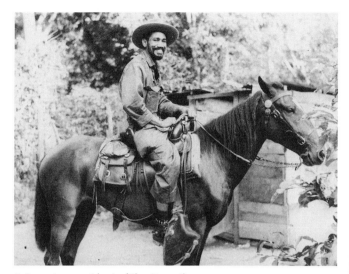

Future vice-president of the Council of State, Commander Juan Almeida Bosque, on horseback.

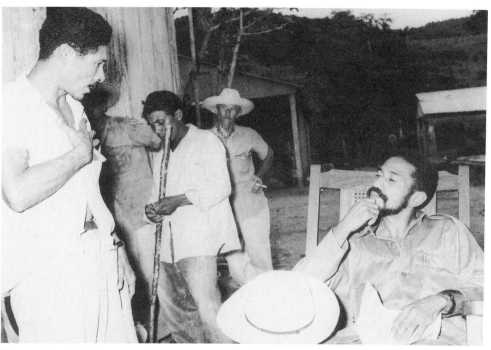

Commander Almeida resting and interviewing a new recruit.

Facing page: Rebel troops join forces before establishing a new front in Las Villas.

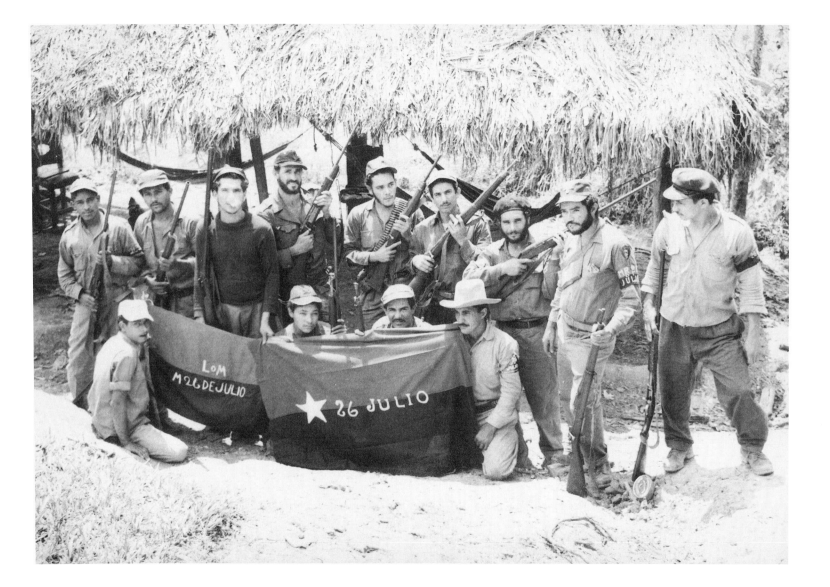

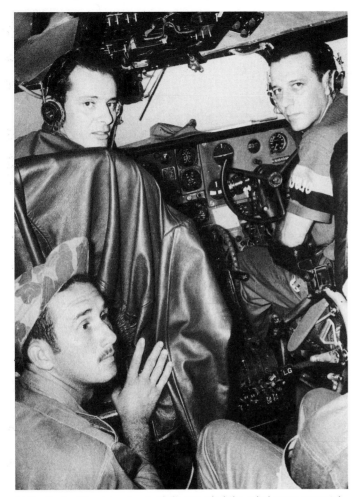

Major Pedro Díaz Lanz (*upper left*) provided the rebel army essential aerial assistance during the war against Batista and became chief of the Air Force after Castro's assumption of power. Six months later, suspecting Communist subversion of the revolution, he defected to the United States, where he testified before a U.S. Senate committee about the growing Marxist influence in Cuba.

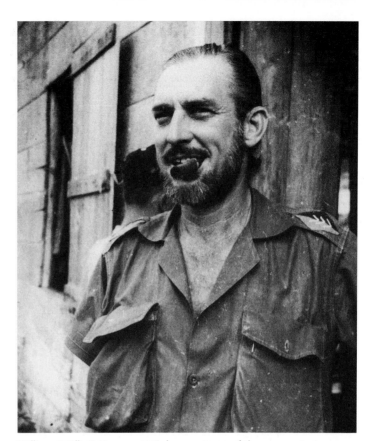

William "Willie" Morgan, U.S.-born veteran of the war against Batista on the Sierra Escambray front. He later entered the opposition against Castro and helped create a guerrilla army made up of ex-students and rebels to overthrow him (once again in the Sierra Escambray). He was arrested in 1960 and, accused of being a CIA operative, was executed in 1961.

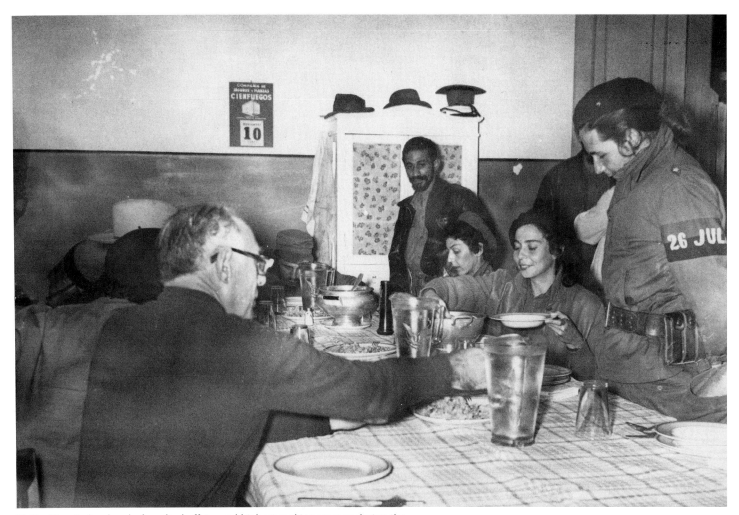

Melba Hernández, head of medical affairs and highest ranking woman during the guerrilla war, at mealtime in the rebel camp sitting next to Vilma Espín (*holding bowl*) and surrounded by Fidel Castro (*sitting, slouched, at the head of the table*), Raúl Castro (*standing, right, with 26th of July armband*), and Juan Almeida Bosque, commander of the revolution (*standing, behind Hernandez*).

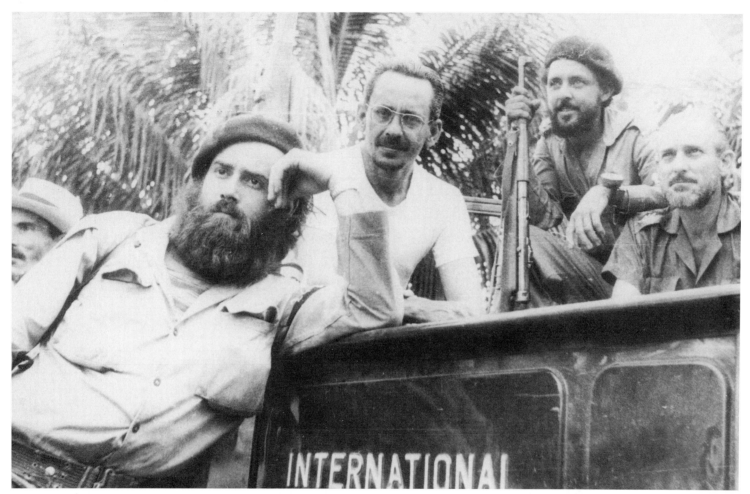

Rebels posing in a Jeep. *From left to right*: Future Communist leader Manuel A. "Barba Roja" Piñeiro, Oriente Fernández, Higinio "Nino" Díaz, and William Morgan. Díaz broke with Castro shortly before Batista's fall because of his concerns over Communist influence in the 26th of July Movement. He later helped form the MRR, one of the leading anti-Castro underground groups in Cuba.

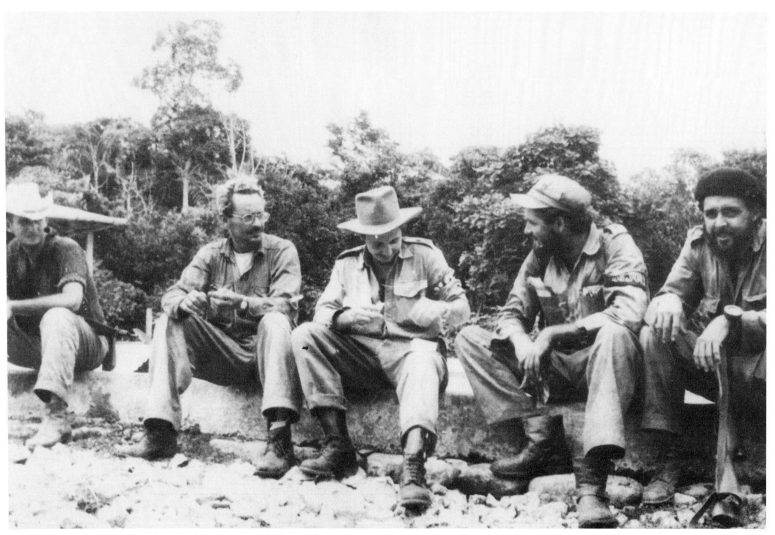

From left to right: An unidentified rebel, Oriente Fernández, Raúl Castro, an unidentified rebel, and Nino Díaz, in northeastern Oriente province.

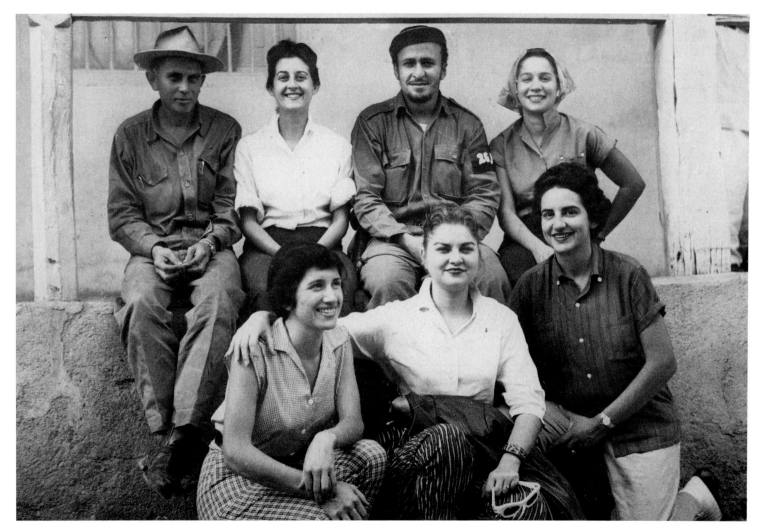

Maria Victoria Pérez Arias (*top, second from left*) was a teacher in Santiago de Cuba and an active sympathizer of the 26 of July movement. She was known to often carry munitions in secret from the city to the mountains.

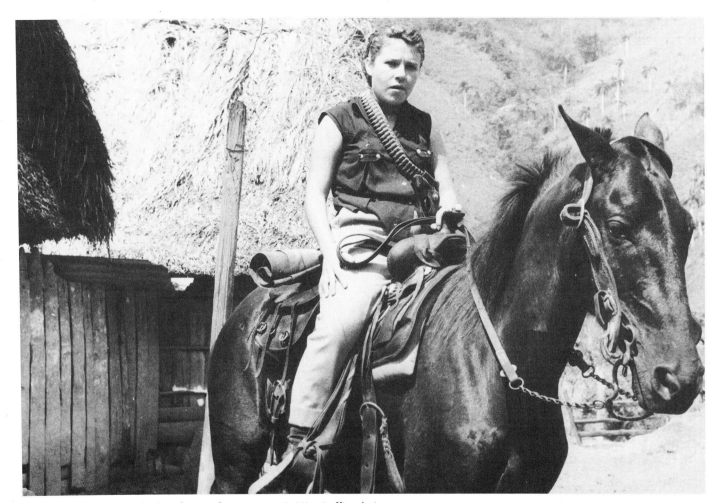

Haydee Santamaría Cuadrado, who ran the movement's Miami office during part of 1958. She participated in the Moncada attack, in which she lost both her boyfriend, Boris Santa Coloma, and her brother, Abél. She committed suicide on July 26, 1980, after announcing to a group of young revolutionaries that, in spite of her sacrifices, she was being ignored by the Castro government.

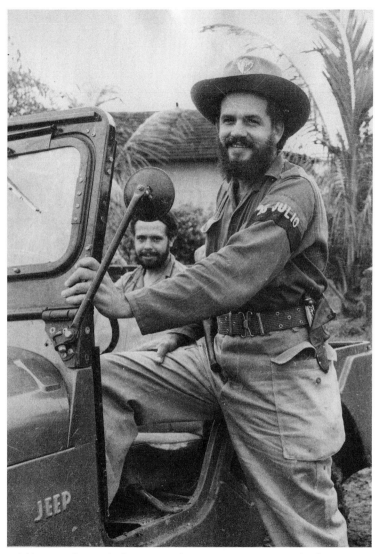

Adolfo Arrazola (inside the Jeep) and Antonio Enrique Luzón, both of whom later became disillusioned with Fidel Castro.

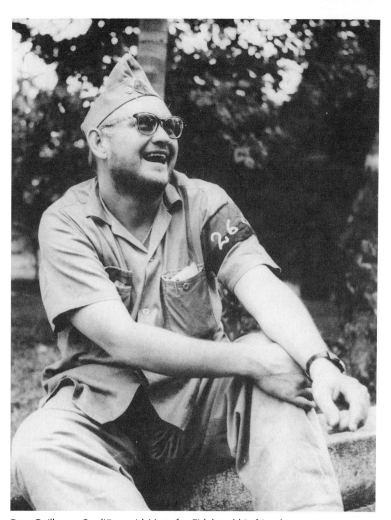

Rev. Guillermo Sardiñas said Mass for Fidel and his friends while in prison. Later, after obtaining permission from Cardinal Archbishop of Havana Manuel Arteaga y Betancourt, Sardiñas became chaplain of the rebel army. Fidel himself designated Sardiñas as commander of the revolution.

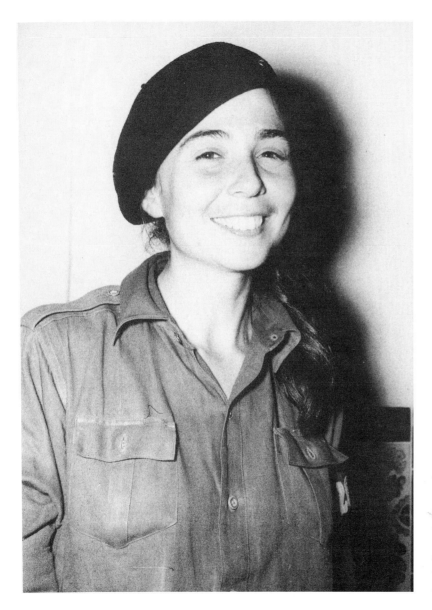

Vilma "Deborah" Espín Dubois was the daughter of an upper-class lawyer and held a chemical engineering degree from the Massachusetts Institute of Technology. She assumed an important leadership role in the revolution (including becoming assistant to Raúl Castro). She later married (and divorced) Raúl Castro, with whom she had four children. Espín was president of the Cuban Federation of Women (FMC), and a member of the National Assembly of Popular Power.

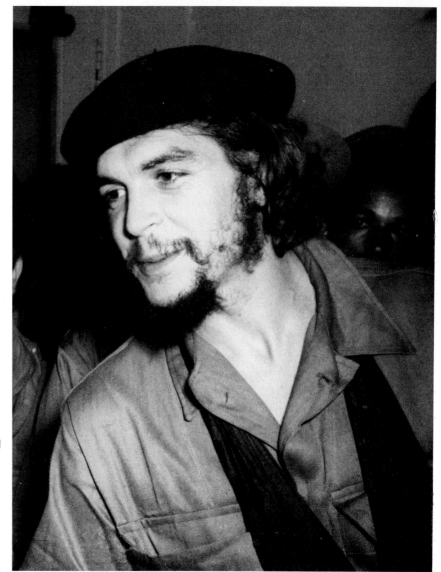

Ernesto "Che" Guevara, an Argentine national, was a medical doctor and international revolutionary. Introduced to Fidel Castro by María Antonia in Mexico City, he was one of the traditional Communists among the leaders of the revolution. He later headed the government's economic efforts as minister of industry and president of the National Bank of Cuba, before resigning in 1965. He was captured and killed in Bolivia on October 8, 1967, while trying to stimulate a peasant uprising there.

Three prisoners.

The modernized guerrilla tactics would
later be copied around the globe.

minican Republic with a handful of friends, leaving thousands of supporters stranded. Those Batista associates with sufficient connections or means, which included those most responsible for the dictator's repression, fled during the night by airplane or boat. The Batista era was over.

On January 1, 1959, the police and army having virtually disappeared, 26th of July and Directorio Revolucionario members kept order on Havana's streets, which experienced less chaos than expected. The rebels remained courteous and polite, making a good impression on the residents of the capital. All over the island, rebels seized government buildings, police stations, army barracks, and communications facilities. Che Guevara took Santa Clara on New Year's Day, then proceeded to Havana, where his forces occupied key military points, including La Cabaña fortress. A force of seven hundred men under the popular Camilo Cienfuegos took over Campamento Columbia, Havana's main military garrison. In Oriente, Fidel Castro, who had been caught off guard by Batista's abrupt departure, entered Santiago de Cuba triumphantly. Batista's pro-democracy opponents in exile returned to Cuba, and low-level Batistianos remaining on the island were taken into custody. Across the nation the people rejoiced and threw their support behind the revolution and a democratic future for Cuba.

Castro's weeklong victory procession to Havana was conducted with a level of drama and pageantry that matched his personality and style. As Havana awaited him with anticipation, he stopped in numerous provincial towns and cities to receive the adulation of adoring crowds and to deliver impassioned speeches. When he finally arrived in the Cuban capital on January 8 with his troops aboard tanks, Jeeps, and trucks, he was received with unprecedented, near-hysterical celebration as Cuba's conquering hero. That night, as he delivered his address via national television, a white dove landed on his shoulder in what many took as an omen.

Even though the rebel "army" really had fought only two major military engagements (Batista's 1958 offensive and Santa Clara), with minimal casualties, the mythical image of Castro created in the Sierra Maestra, amplified now by Batista's flight and the triumphal march across Cuba and into Havana, ensured that Castro would remain the revolution's most popular leader. Castro's extraor-

dinary charisma and mesmerizing speeches, combined with the national euphoria over the successful revolution, brought hundreds of thousands of formerly neutral Cubans to support him. Revolutionary leaders, taking full advantage of the nation's emotional state, continued to encourage a cult of personality around Cuba's new messiah. Placards reading "Thank you, Fidel," and signs hung on doors reading "Fidel, this is your home" became common. Hugh Thomas, a leading authority on the period, correctly stated that "while before 1 January he had only a handful of followers, within weeks many thousands believed that he could do no wrong."[39] The momentum Castro established also allowed him to ignore his promises to other resistance groups in the Caracas Pact.

Among the new regime's first acts were to abolish political parties, concentrate all power in the cabinet, and postpone the promised elections for eighteen months.[40] These moves led many, including numerous revolutionaries who saw past the emotional frenzy of the moment, to become suspicious about Castro's true intentions. They began to wonder if they had been duped and the rumors of a Communist conspiracy were true. Contributing to these fears was the wave of revolutionary terror the Castro regime unleashed during its first weeks in power. Sham trials conducted before vindictive, bloodthirsty crowds shouting "*¡Paredón!*" (To the execution wall!) were followed by firing-squad executions. The total lack of legal process, as well as the bloodlust encouraged at the popular level, revolted true democratic reformers. The executions stood in sharp contrast to how Castro's people had treated captured enemy soldiers during the guerrilla war, when most were accorded rather humane treatment as prisoners. In defending the illegal postwar executions, Castro set the tone for the arbitrary and political nature of legal decisions in the new Cuba, stating, "Revolutionary justice is not based on legal precepts, but on moral conviction." Che Guevara, who as commander of La Cabaña fortress from 1959 to 1963 ordered the execution of hundreds of Cubans without trial, said, "To send men to the firing squad, judicial proof is unnecessary. These procedures are an archaic bourgeois detail. This is a revolution! And a revolutionary must become a cold killing machine motivated by pure hate. We must create the pedagogy of the paredón!"[41]

Also alarming to many Cubans in 1959 was the blatant Communist indoctrination of the armed forces by Guevara and other revolutionary leaders.[42] The first major alarm bells in this regard were sounded by Major Pedro Díaz Lanz, an anti-Batista rebel who resigned as Castro's chief of the Air Force in mid-1959 and sought asylum in the United States. His testimony before the U.S. Senate Internal Security Subcommittee that Castro was a tool of international Communism was derided in the U.S. press (including by Herbert Matthews and the *New York Times*), which tried to discredit Díaz Lanz and dismissed his accusations.[43]

In order not to lose the support of the middle class before he consolidated his power, Castro continued to deny that he was a Communist and filled his initial cabinet with well-known, anti-Batista liberal democrats. As he became more politically entrenched over the next several months, however, the liberals were purged and replaced by Communists and close Castro allies.[44] Some of Castro's own rebel comrades from the war were imprisoned or executed or died mysterious deaths when they openly questioned the direction the revolution was taking.[45] The most spectacular cases were those of rebel chief Huber Matos, who was given a twenty-year sentence in 1959 for questioning Castro's ties to Communism, and Camilo Cienfuegos, whose Cessna suspiciously disappeared between Camagüey and Havana a week after Matos's arrest. By the time it became obvious that Castro had abandoned the revolution's original ideals and was leading Cuba into Communism, he controlled the armed forces, had created an efficient system of internal state security, and had brought legions of new followers under his personal banner.

The battle lines between Communism and democracy in Cuba were firmly drawn in 1960. Soviet Deputy Premier Anastas Mikoyan visited the island in February, and the Castro regime subsequently established diplomatic relations and signed a commercial agreement with the Communist superpower. Also in 1960, Castro's government began taking over the island's public and private institutional structure. The labor unions were brought under Communist control, freedom of the press was permanently ended, and the government confiscated and monopolized all media, allowing it to conduct mass propa-

ganda and social indoctrination. The government also began to expropriate numerous private businesses, launched a fierce antireligious campaign, and ended the autonomy of the University of Havana. The promised elections, meanwhile, were replaced by the cynical slogan, ¿Elecciones, para qué? (Elections, what for?).[46]

Democratic opposition to the new regime quickly arose and included many people who had previously fought against Batista. Castro's political police pursued the activists, and those who were caught were executed or given decades-long sentences in the regime's nightmarish political prison system. In their entire history the Cuban people had never, even in the worst days of Batista, been subjected to such levels of violence by their government. Moreover, Castro's anti-Americanism, something his propaganda machine had skillfully concealed during the guerrilla war, surfaced as he delivered hysterical and incessant diatribes against the United States. Relations between Cuba and the United States were severed in January 1961.

Many who had helped Fidel Castro rise to power, especially the largely anti-Communist Cuban middle class, felt betrayed. In their estimation Castro had manipulated them with promises of democracy to get into power and then installed a Communist dictatorship. Mario Llerena, a one-time leader in the 26th of July's Committee in Exile, described Castro's manipulation as an "ideological sleight of hand," and stated that "without realizing it, the middle class was actually used as the disposable booster of the camouflaged Communist rocket until it reached its planned orbit in power. Then there was no longer need for a middle class."[47] Along with other sectors of the population, many middle-class Cubans found the prospect of living under a totalitarian system unacceptable. Parents were particularly alarmed when plans surfaced to shut down the island's schools and replace them with schools and youth programs that aggressively indoctrinated children in Communist militancy, atheism, and adoration of Fidel Castro. To them, the regime seemed prepared to take whatever measures were necessary to condition the next generation for its own political purposes, even if that meant an ideological (and, many feared, physical) separation of children from their families.[48]

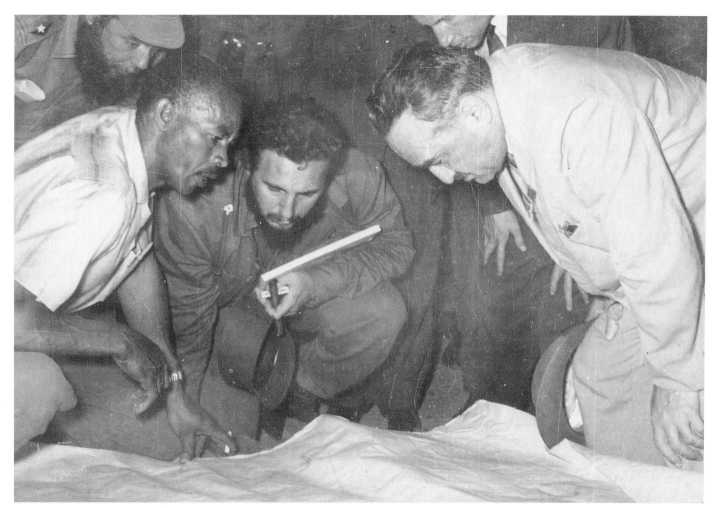

Fidel Castro and others looking at a map of Santiago de Cuba.

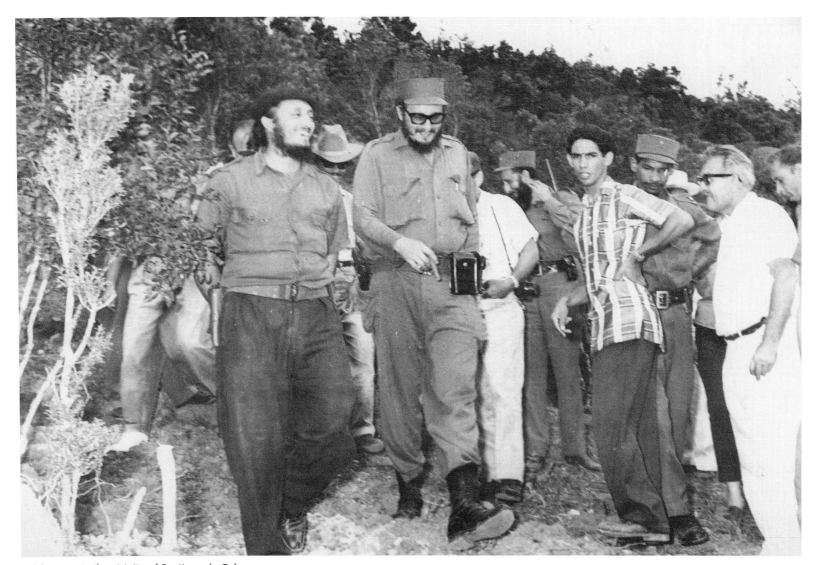

Fidel Castro in the vicinity of Santiago de Cuba.

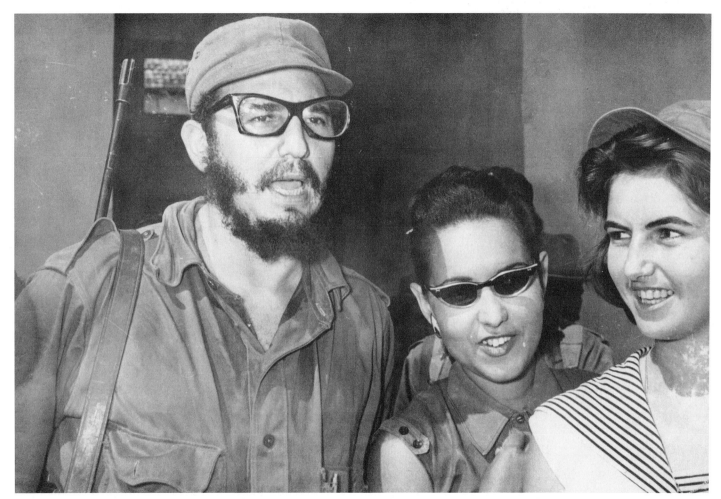

Fidel chats with young female supporters in Santiago de Cuba.

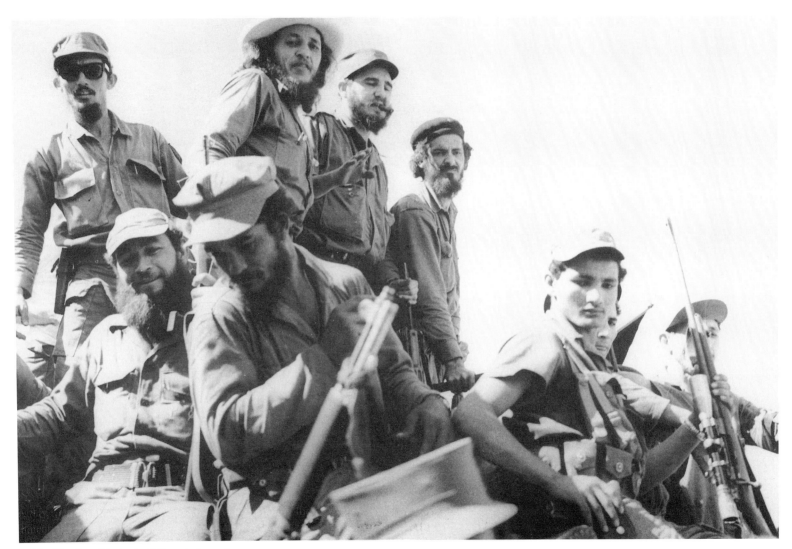

Fidel with other "Barbudos" (bearded ones),
during their final push to Santiago de Cuba.

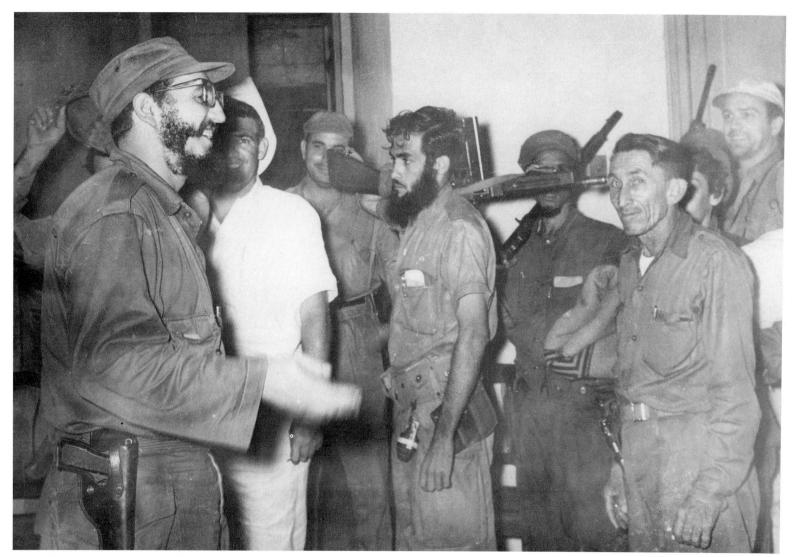

Fidel with fellow rebels and sympathizers in Santiago de Cuba.

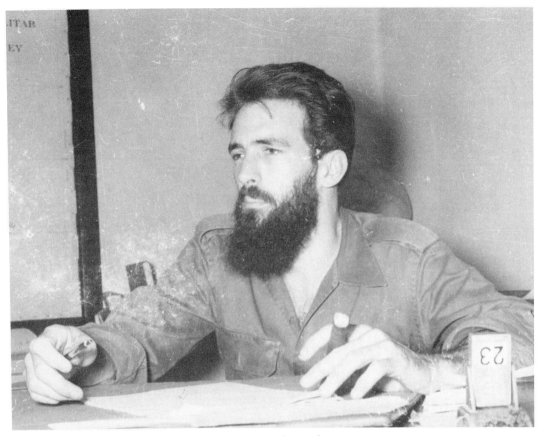

A beloved and popular rebel leader, the handsome Camilo Cienfuegos was reportedly upset at Castro's treatment of Huber Matos. A week after Matos was arrested, a Cessna airplane carrying Cienfuegos from Camagüey to Havana disappeared under extremely suspicious circumstances. Many Cubans, both in exile and on the island, are certain that Fidel Castro assassinated Cienfuegos.

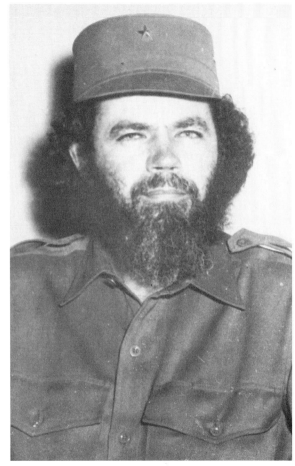

Rebel commander Huber Matos, the military governor of Camagüey, was given a twenty-year prison sentence by Castro in the fall of 1959 when he raised questions about the revolution's apparent turn toward Communism. After his release from prison in 1979 he went into exile and formed the anti-Castro group Cuba Independiente y Democrática (Independent and Democratic Cuba).

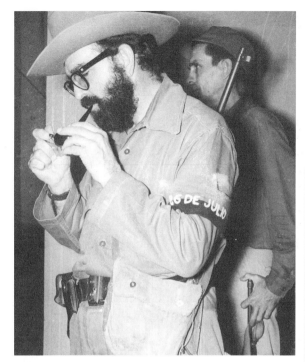

Raúl Chibás, ex-president of the Ortodoxo Party and brother of party founder Eduardo Chibás, was captured and imprisoned by the Batista regime. Later he received asylum at the Argentine Embassy in Havana and organized arms shipments to the rebels from the United States.

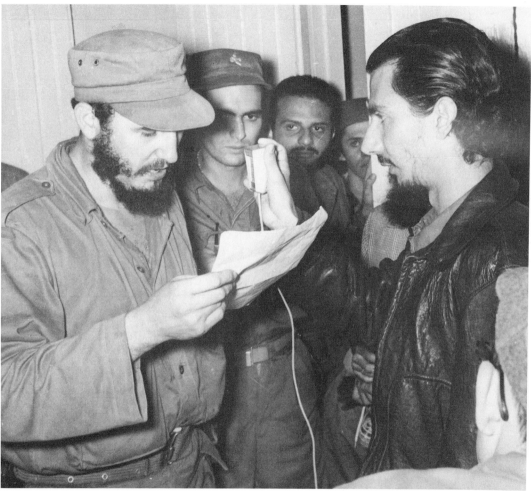

Jorge Enrique Mendoza, of Radio Rebelde and later of the newspaper *Granma*, with Castro.

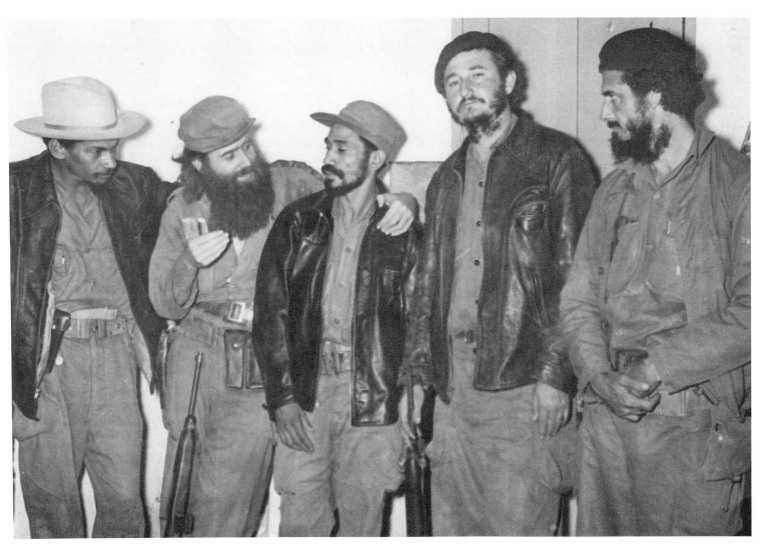

Juan Almeida (*center*), commander of the revolution,
relaxes with friends during the celebrations.

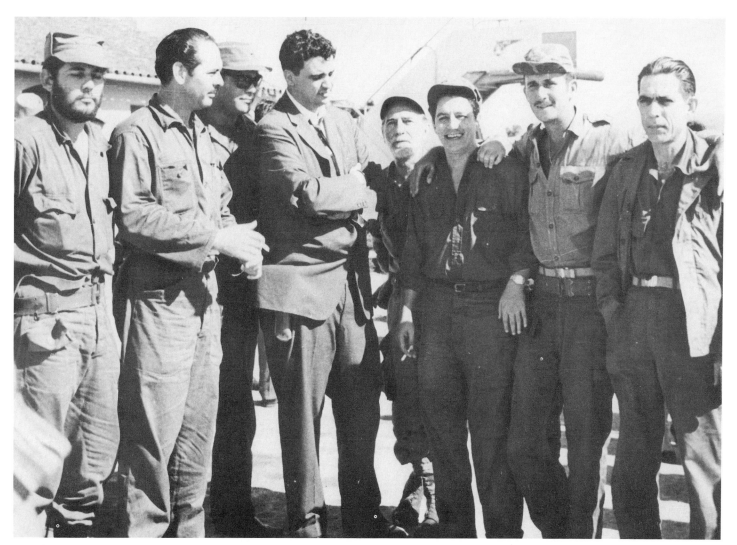

José Llanuza Gobel (in suit), a member of the 26th of July underground
and a community leader, greets the rebels at the Santiago de Cuba airport.

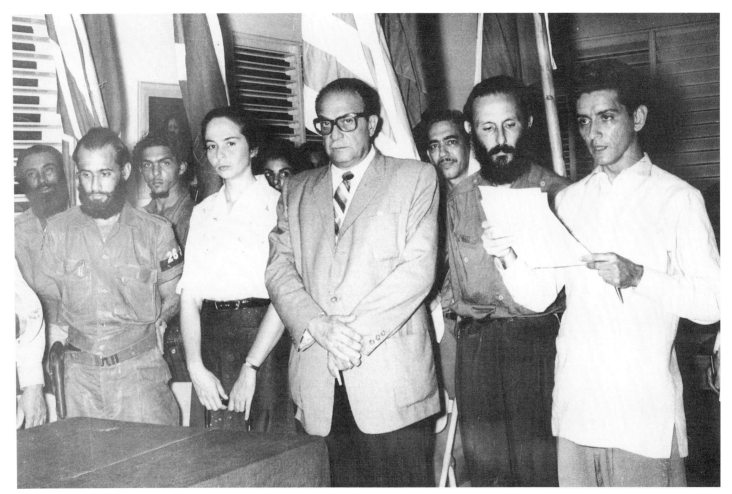

Euclides Vázquez Candela reads from a prepared statement accepting the surrender of Batista's forces to the rebels. Carlos Franqui (director of Radio Rebelde), José Miró Cárdona (*in center, with coat and tie*), who became the first prime minister of the new government, and Vilma Espín look on.

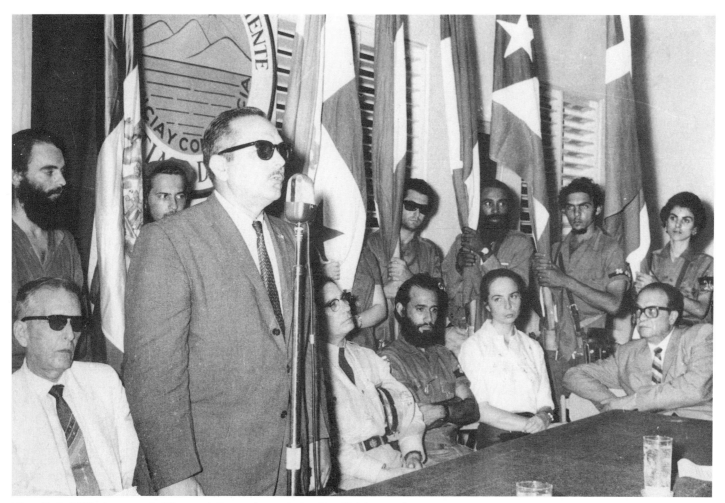

Vilma Espín (*sitting*) represented the revolutionary forces during the official surrender in Santiago de Cuba. Speaking to the delegation is Dr. Manuel Lleo Urrutia, a judge friendly to the rebels who became Cuba's president after the rebel victory. Urrutia was forced out by Castro several months later. Many of those pictured who represented the Batista government were later executed by firing squad.

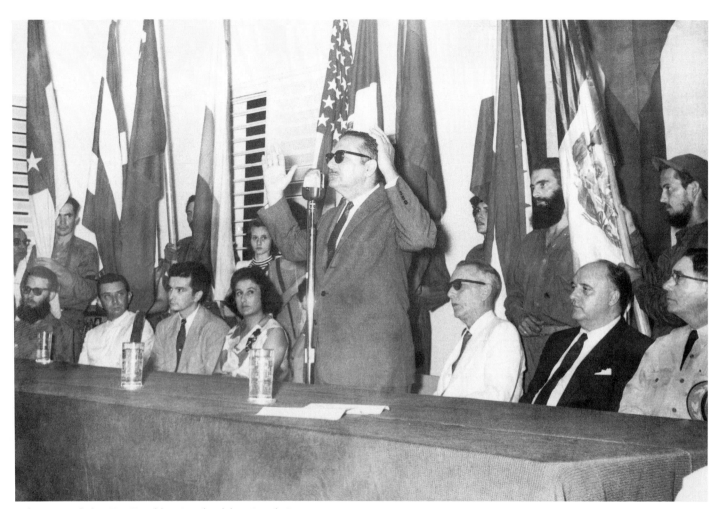

Judge Manuel Lleo Urrutia addressing the delegation during
the official surrender in Santiago de Cuba.

U.S. Ambassador to Cuba Earl T. Smith approves the change in power with friend and local businessman Felipe Valls at his side.

Col. Rego Rubido (*in uniform*) and other Batista representatives standing for the 26th of July anthem.

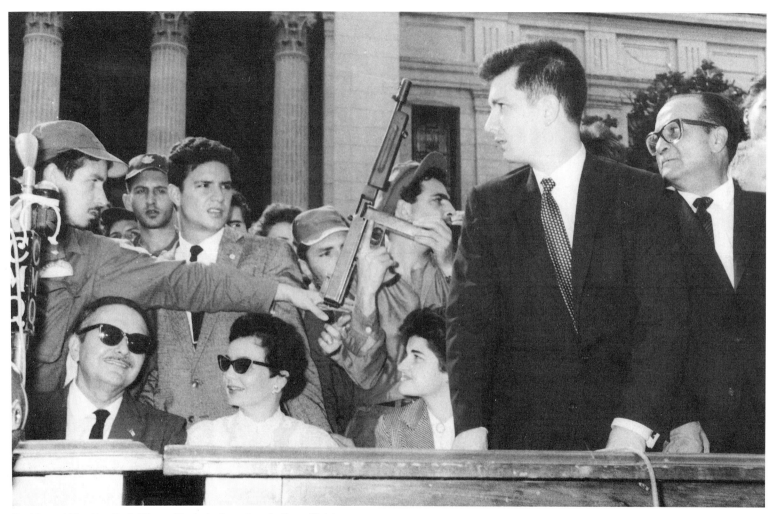

Dr. Manuel Lleo Urrutia (*sitting with dark glasses*) and other officials
from Santiago de Cuba waiting to address the public.

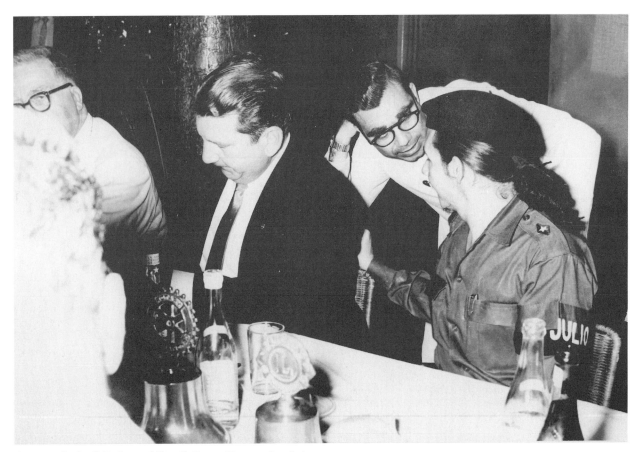

Commander Raúl Castro and Eloy Gutierrez Menoyo (*center*)
are greeted by Father Jorge Bez Chabebe of the La Salle
Catholic prep school at a Rotary Club meeting.

Facing page: From left to right: Commander Belarmino "Anibal" Castilla,
Commander Villa Montseny, Commander Manuel "Barba Roja" Piñeiro,
Commander Nicaragua Iglesias, and Commander Díaz Lanz. Standing
behind them is commentator Carlos Estrada from La Fabulosa radio station.

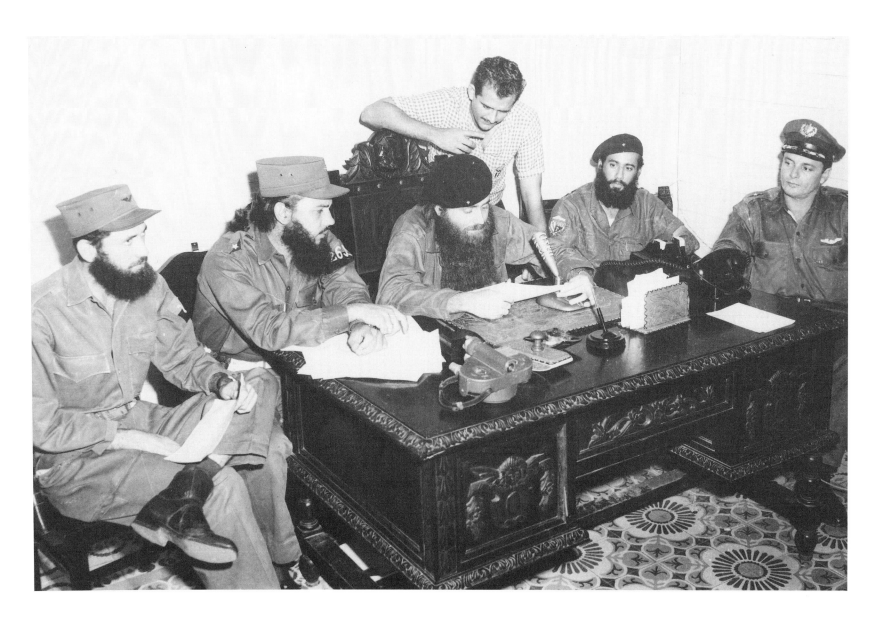

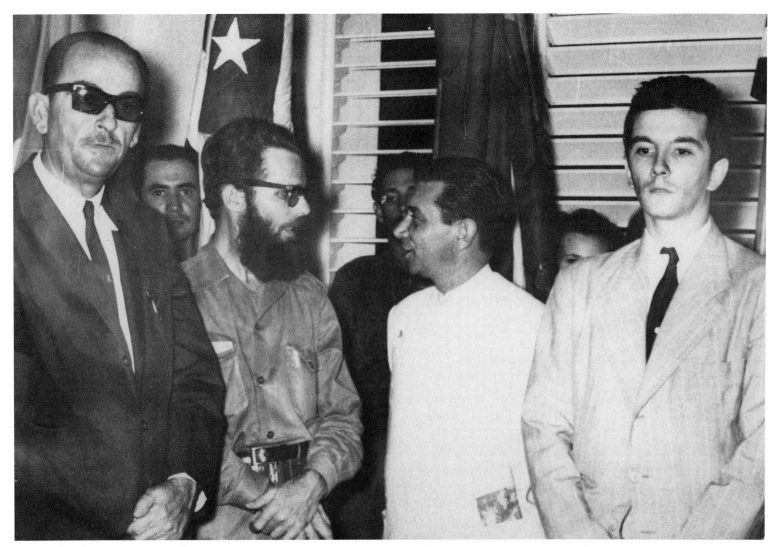

Armando E. Hart (*far right*), leader of the underground movement in Havana, attends the ceremonies with coleaders Faustino Pérez (*center*) and Ángel Fernández (*far left*).

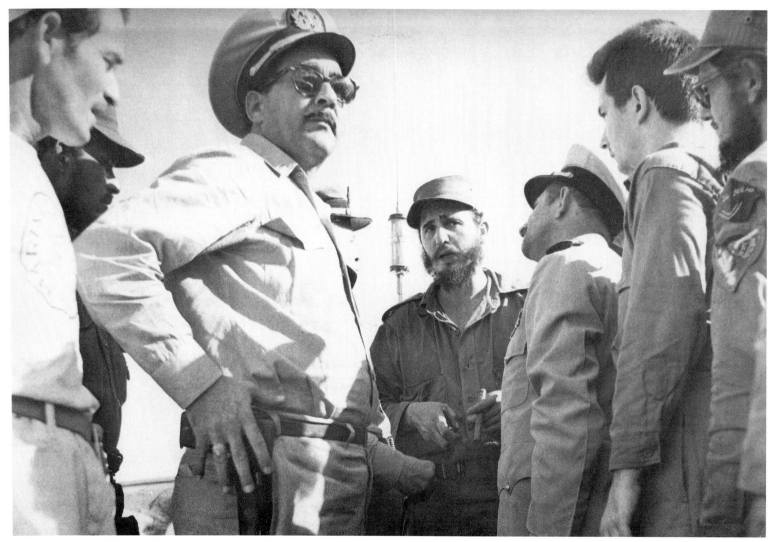

Fidel Castro with rebel spy and Batista army officer Adolfo López-Campos (to the right of Castro), known to the rebels and the Communist Party as "Stirson."

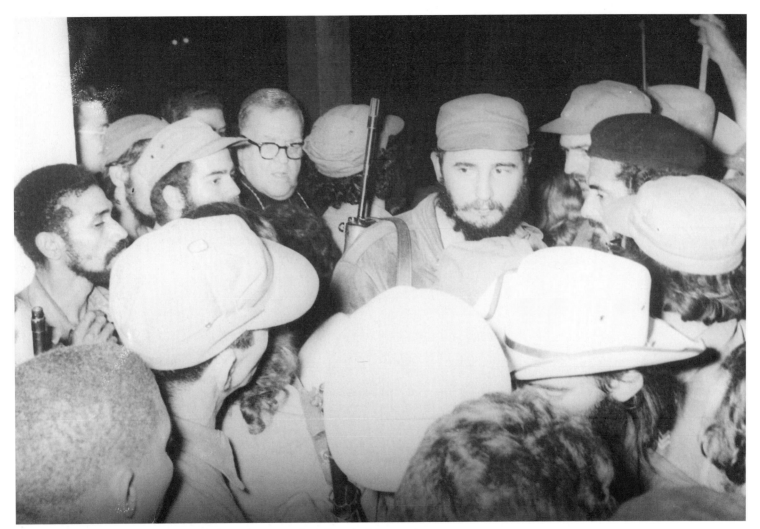

Monsignor Enrique Pérez Serantes, archbishop of Santiago de Cuba, who intervened
to save Fidel Castro's life after the Moncada attack, enters Santiago de Cuba with the
rebel leader in January 1959.

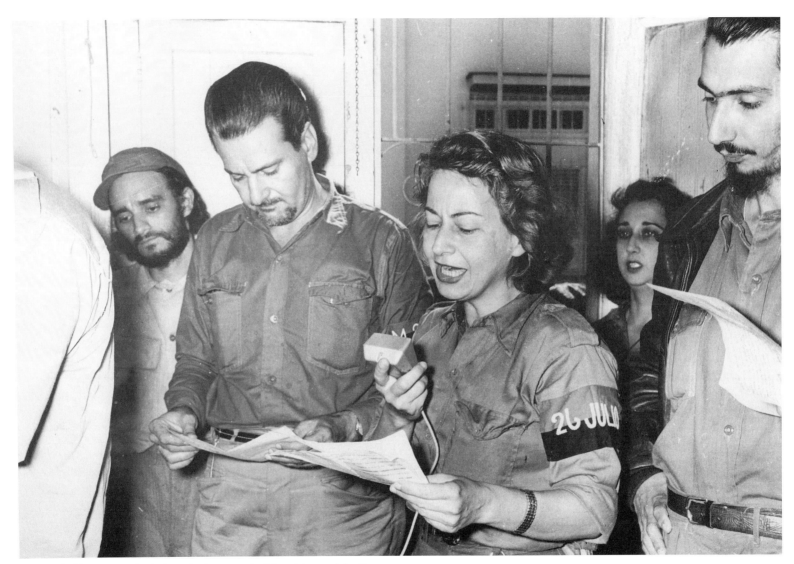

Radio Rebelde gave a minute-by-minute account of the victory celebrations.

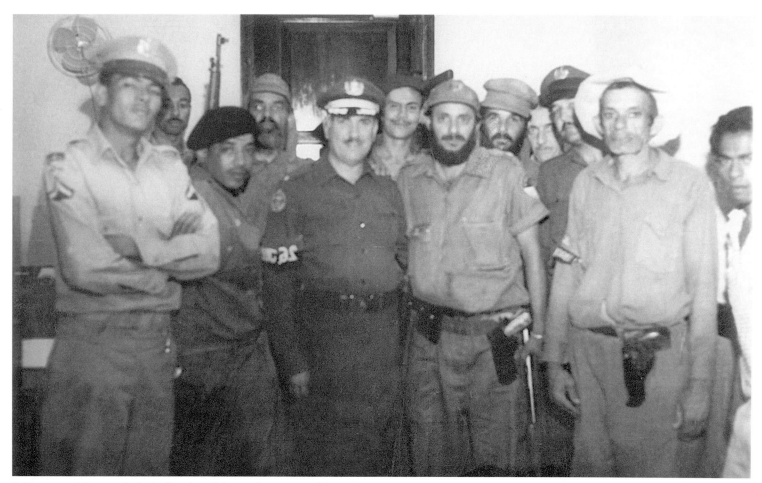

Policemen, soldiers, and rebels all gathered during the victory celebrations.

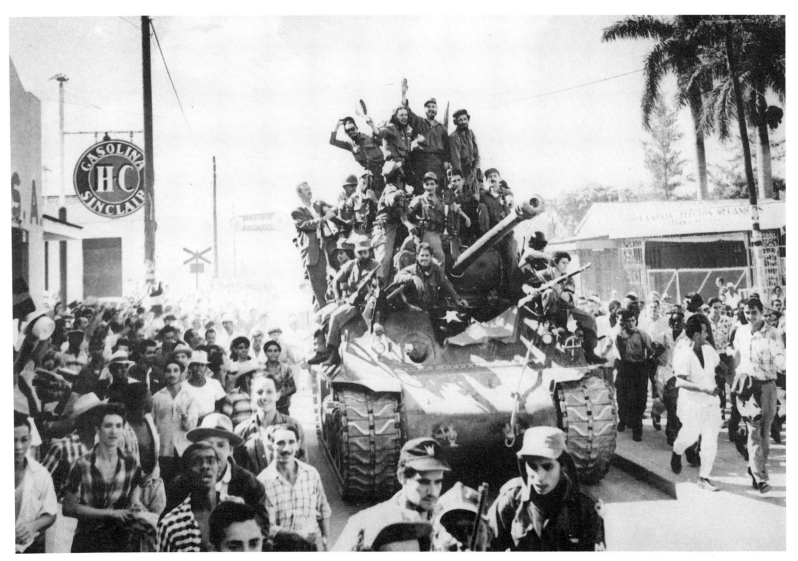

Triumphant rebels enter Havana.

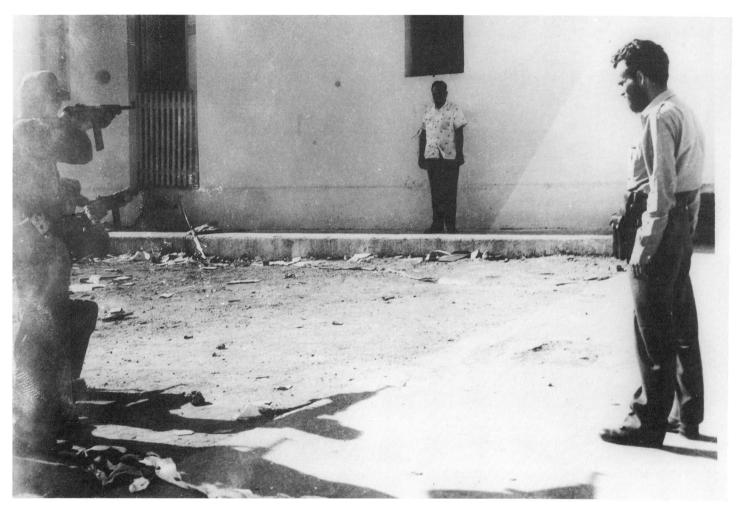

Alejandro García Olayón, Batista's chief of maritime police in
Santiago de Cuba, was one of many who faced the firing
squad in the days after the victory, on January 2, 1959.

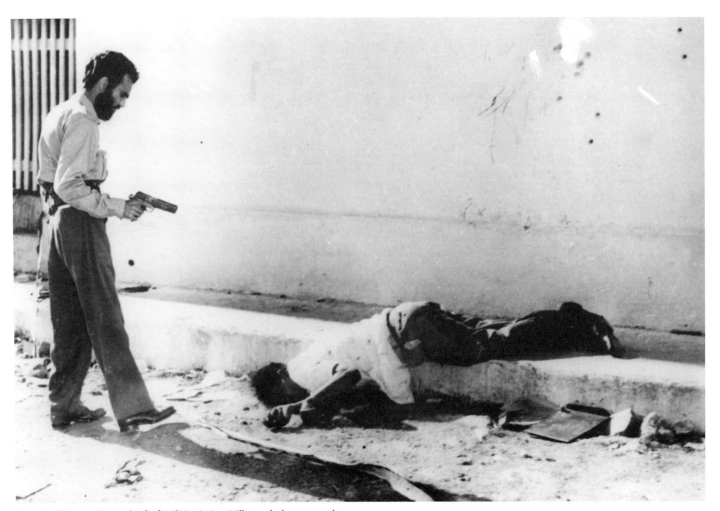

René Rodríguez Cruz, chief of militias in Las Villas, rebel commander,
and chief executioner, delivers the coup de grâce.

Consequently, thousands of families joined a desperate, massive, and unprecedented wave of Cubans fleeing the island. Parents who could not leave immediately sought to prevent their children from being brought up in a totalitarian system by sending them abroad through a semisecret program dubbed by the press as Operation Pedro Pan. Established by the Cuban underground, the Catholic Church in Cuba, the U.S. State Department, and Father Bryan Walsh of the Catholic Welfare Bureau in Miami, Florida, Operation Pedro Pan rescued more than fourteen thousand children from Communist Cuba between December 1960 and October 1962. Once in the United States, those children who had no family in the country that could care for them (around half) were sent into the federally funded Cuban Children's Program. Overseen by Father Walsh and carried out by Catholic, Protestant, and Jewish humanitarian agencies, the Cuban Children's Program placed the children in multiple types of living arrangements across the United States until they could be reunited with their parents. For some, this reunion came within weeks or months; others, tragically, had to wait years.[49]

Coincident with the dramatic flight of Cubans from the island, the idea of ousting Castro militarily gained strength among pro-democracy Cubans and the U.S. government. The United States, which had indirectly helped Castro to power by cutting off military aid to Batista, had no desire for a Communist dictatorship ninety miles from its shores. Pro-democracy Cubans, meanwhile, were determined not to allow a Communist, totalitarian takeover of their homeland. By mid-1960, Cuban opposition groups had organized in Miami, Florida, and their networks worked clandestinely against Castro on the island. The principal opposition leaders were highly respected Cuban liberals who had played a major role in ousting Batista; some had even served in Castro's first government. With the prodding of the United States, the often competing and quarreling exile groups joined forces to create the Frente Revolucionario Democrático Cubano (later called the Cuban Revolutionary Council) to bring unity to the anti-Castro cause.

The Frente Revolucionario Democrático Cubano, in alliance with the U.S. government, recruited exiles to oust the Castro regime, forming the so-called

Liberation Army. Driven by democratic principles, patriotism, religious zeal, and a profound sense of purpose, men of all ages and social classes—from peasants to former ambassadors—joined the Liberation Army, which took the name Brigade 2506 (the serial number of Carlos Rodríguez Santana, the first recruit, who died in training).[50] U.S. military personnel trained the brigade primarily in Central America, and the CIA was given overall responsibility for the operation. Brigade 2506, which had fewer than two thousand men, consisted of ground forces, a heavy weapons battalion, an armored battalion, a tank unit, a paratrooper unit, a naval arm, an infiltration team, and an air force of B-26 bombers and transport planes.

The invasion plan called for the brigade's land, sea, and air forces to create an impenetrable beachhead in Cuba where a provisional democratic government-in-arms, dedicated to the Constitution of 1940, could be established. Once entrenched, the brigade and the provisional government would receive support, diplomatic and otherwise, from the United States and Latin American nations. Shortly before the invasion, it was decided that José Miró Cárdona, the former head of the Caracas group and Castro's first prime minister, would be the provisional president. Although the mission was extremely dangerous, Brigade 2506 was willing to face any risks to liberate their homeland from Communist rule. Comforted by their alliance with the world's greatest democracy and convinced of the righteousness of their cause, the brigade was supremely confident of success. The high morale and political astuteness of this citizen-army, which was disproportionately middle class and contained few men with previous military experience, earned it the deep respect of its American trainers.[51]

John F. Kennedy assumed the U.S. presidency shortly after the invasion plan was formulated. The new president, concerned with concealing the U.S. role in the operation, insisted that the landing site be changed from the city of Trinidad (an ideal site for such an operation) to a more remote spot. He later approved a new landing area around the Bay of Pigs, near the Zapata swamp on Cuba's southern coast, a far inferior site. The president, again placing political ahead of military considerations, then made destructive changes to the air plan upon which the invasion's success hinged. First, he drastically reduced the number of

pre-invasion-day strikes against Castro's air force by the brigade's B-26 bombers. Then, just hours before the brigade began landing in Cuba on April 17, 1961, Kennedy canceled the remaining air strikes altogether. This action sacrificed the total air supremacy needed for success, doomed the invasion to failure, and effectively sealed Cuba's fate.[52]

Abandoned by the U.S. government and facing an overwhelming force with virtually no air power and one day's worth of supplies (their supply ships were forced to flee because of President Kennedy's changes to the air plan), the tiny brigade force of around 1,300 that landed nevertheless fought with great ferocity. Refusing to believe the United States would not stand by them, Brigade 2506 dug in and held the beachhead for three days, giving up the fight only after they ran out of ammunition. By the time it was all over, Brigade 2506, pound for pound clearly the superior force, had inflicted thousands of casualties upon the enemy while suffering only 114 deaths itself.[53] When the beachhead finally collapsed, the men of the brigade attempted to escape through the swamps, but they were rounded up by Castro forces and imprisoned. It was not until December 1962, more than twenty months after the invasion, that the United States traded the brigade prisoners for $62 million worth of pharmaceutical supplies and baby food. The *African Pilot,* which transported the first shipment, returned to the United States with brigade members' relatives who had remained in Cuba. Many of the prisoners had originally left Cuba for the United States with their relatives, or their relatives were in the United States during the invasion. Some of them had family in Cuba during their imprisonment and their families were able to come on the ship. The exodus that had begun before the invasion continued until the missile crisis, when it was shut down.

The exile community received Brigade 2506 as returning heroes. A few days after their arrival, the men gathered once more as a group for a ceremony with President Kennedy at the Miami Orange Bowl. Like the thousands of Cuban exiles in attendance, the brigade was extremely resentful of Kennedy for having abandoned them. They nevertheless presented the young president with the brigade flag and cheered wildly when he stated, "I can assure you that this flag will be returned to this brigade in a free Havana!"

Although Kennedy's promise has not come to pass, the men of Brigade 2506 have remained the heroes of the Cuban exile community—a community whose numbers have multiplied for more than four decades with Castro's continued rule in Cuba. For them, Brigade 2506 remains a symbol of hope and of the long-held but elusive dream of a democratic Cuba.

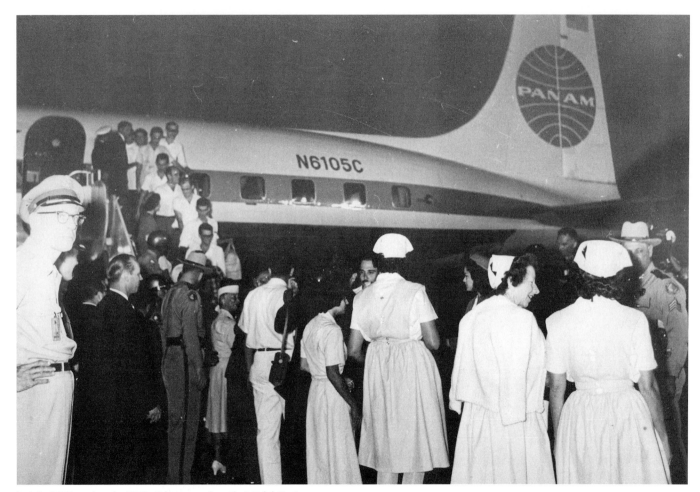

In late 1959 and early 1960, it became clear that Fidel Castro
planned to establish a totalitarian Communist state, triggering
the exodus of hundreds of thousands of Cubans.

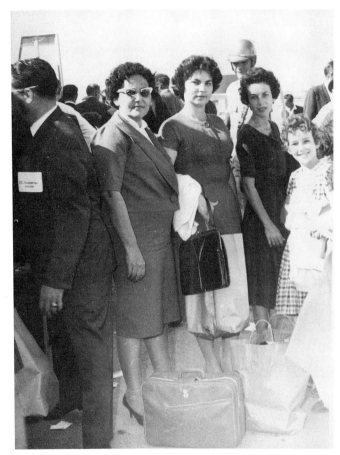

A Cuban family having just arrived in Miami. Many Cubans did not unpack their suitcases for months, expecting to return home very shortly.

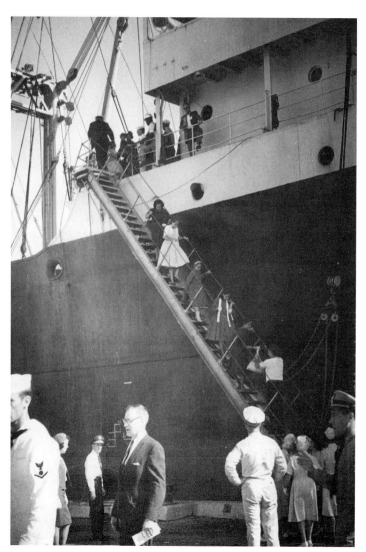

Cuban exiles disembarking from the *African Pilot* in the United States. Both the Eisenhower and Kennedy administrations accepted Cubans with open arms on humanitarian grounds. The *African Pilot* was chartered by the U.S. Department of Commerce, first to facilitate the exodus and later to deliver humanitarian cargo in exchange for Bay of Pigs veterans.

By October 1962, 14,048 Cuban children had been sent unaccompanied to the United States through Operation Pedro Pan.

The Cuban exiles received a warm welcome from their English-speaking neighbors in Florida. Here the Red Cross assists refugees. The American Red Cross and the Cuban Red Cross acted as mediators between the United States and the Cuban government to facilitate the exchange of prisoners for aid.

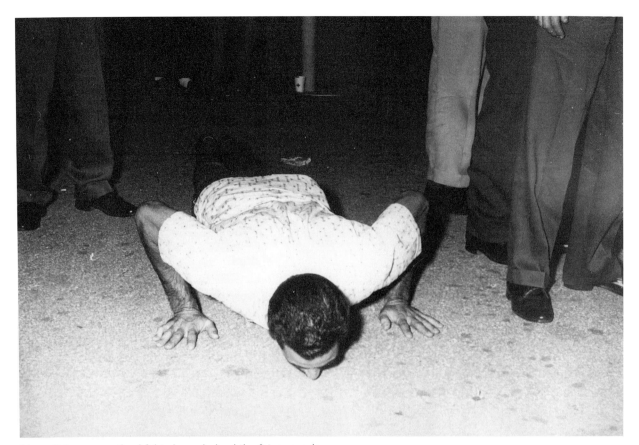

Many Cubans were thankful to have dodged the firing squads and found freedom in the United States. Exiles often kissed the ground as an expression of their thankfulness.

Cuban refugees boarded buses for
processing by U.S. immigration.

Cuban exiles rally at Miami Stadium (later known as the "Bobby Maduro" Baseball Stadium) to urge the U.S. government to take military action against the Castro regime. Such demonstrations became common.

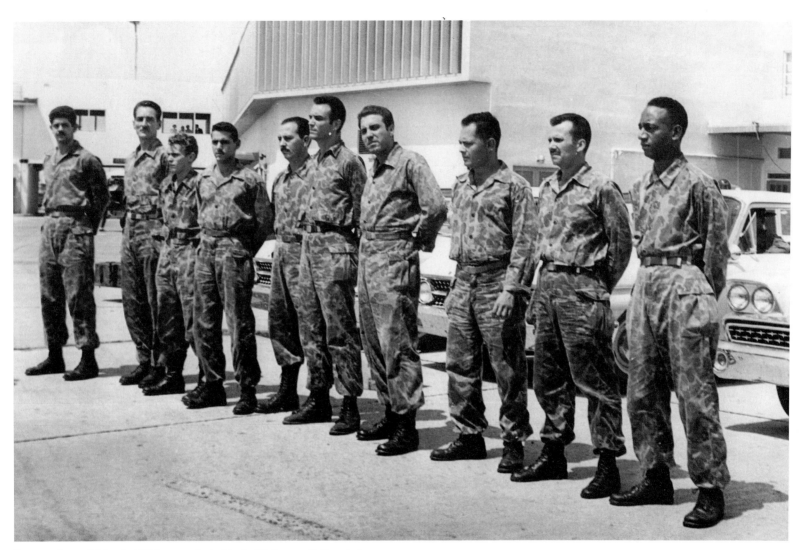

Ten members of Brigade 2506 were selected to facilitate negotiations between
the American and Cuban Red Cross and the U.S. and Cuban governments.

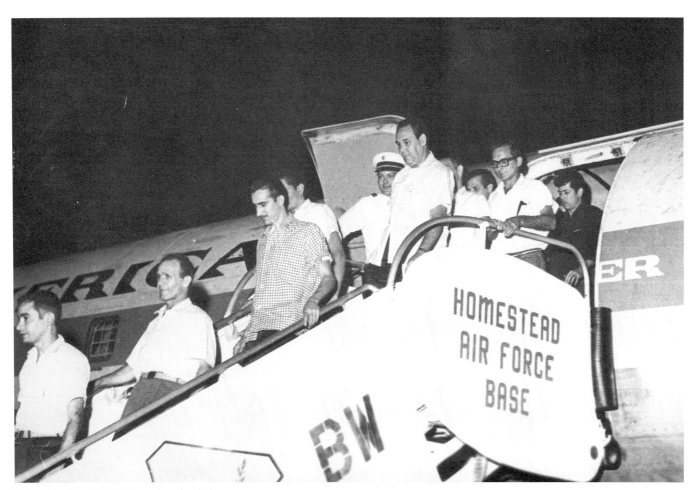

Returning Brigade 2506 members landed
at Homestead Air Force Base in Florida.

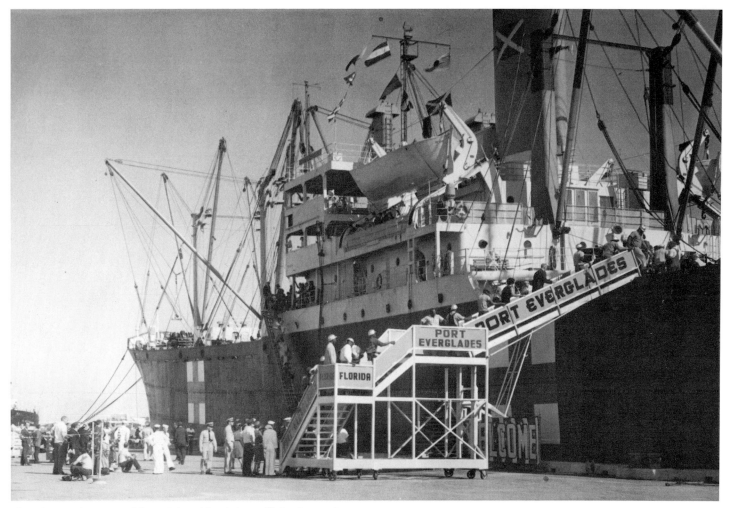

The *African Pilot* returned from Cuba with relatives of brigade members.

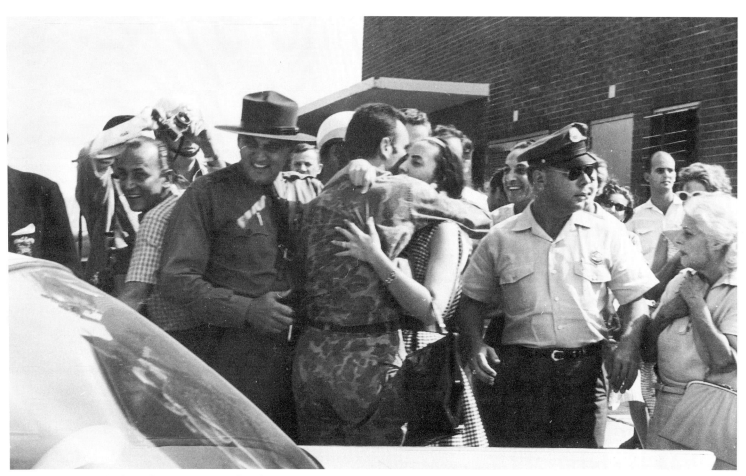
Families are reunited after at least twenty months of separation.

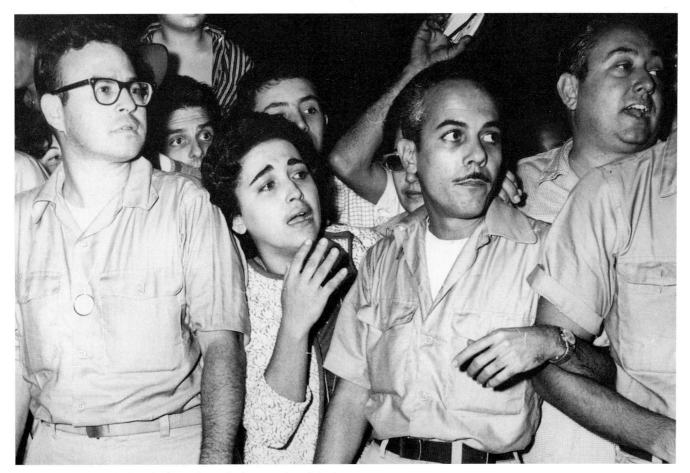

Some didn't know whether their loved ones had survived until the last moment.

Facing page: Relatives cross security lines to hug their brigade family members.

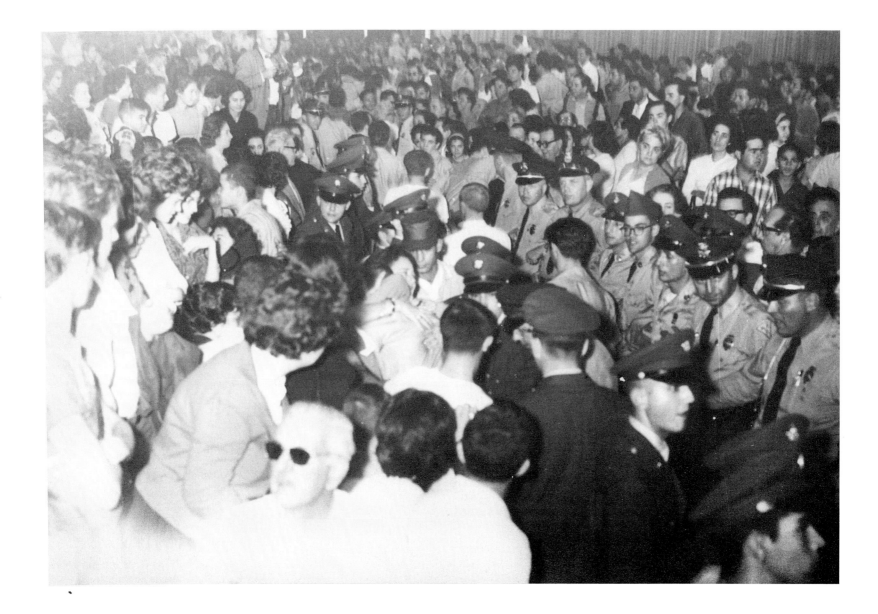

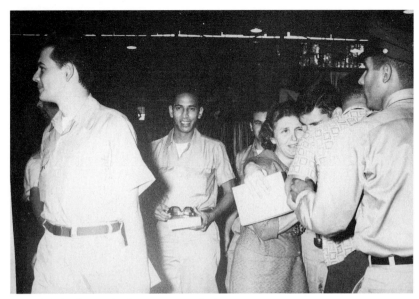

As each brigade member's name was called over the loudspeakers, relatives and friends rushed to hug their heroes.

Some of the 1,113 surviving brigade members, whom Castro exchanged for $62 million in medical and pharmaceutical supplies.

Brigade members went from party to party, celebrating their return.

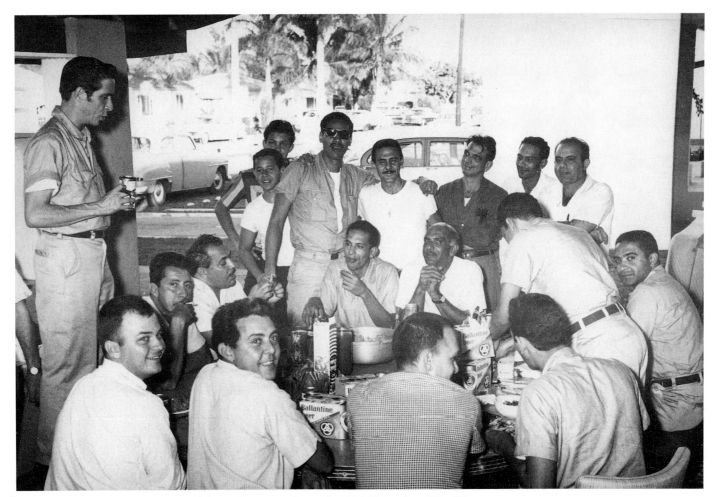

Former supporters of the revolution celebrate the return of Brigade 2506. Pictured are Nino Díaz (*seated center front*); Teófilo "Tofi" Babún (*right rear*); unknown person next to Babún; Alejandro Bauza (*standing, next to unknown person*); future Hialeah, Florida, mayor Raúl Martínez (*standing, center rear*); Martínez's father, "Chin" Martinez (*sitting left rear*); Enrique Calas (*sitting, center rear*), and his three sons, Manolo, Freddy, and Kiki, all members of the brigade.

Members of Brigade 2506 at the Miami Orange Bowl at the ceremony honoring their return. The soldiers came from all sectors of society and regions of the island.

Brigade 2506 Commander José Pérez San Román welcomes
President and Mrs. Kennedy to the podium.

First Lady Jacqueline Kennedy charmed
the crowd by addressing them in Spanish.

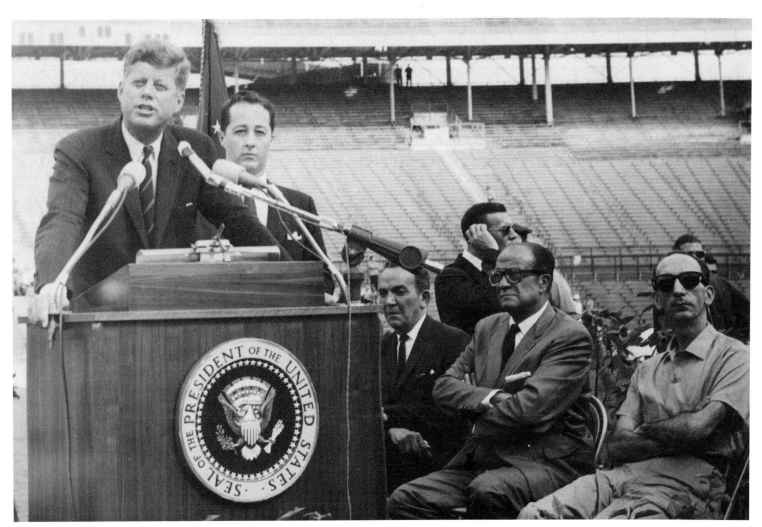

President Kennedy officially welcomes Brigade 2506 before
twenty thousand exiles in the Orange Bowl. Sitting to his
left, wearing glasses, is José Miró Cárdona.

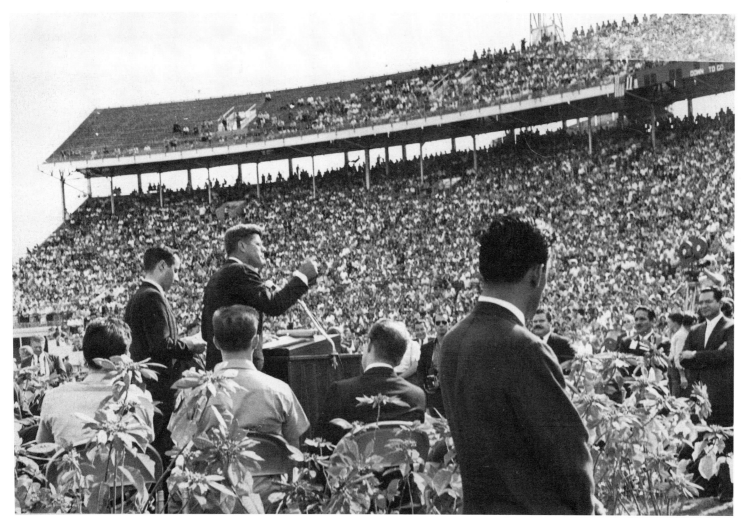

President Kennedy promises the liberation of Cuba
before the end of his term in office.

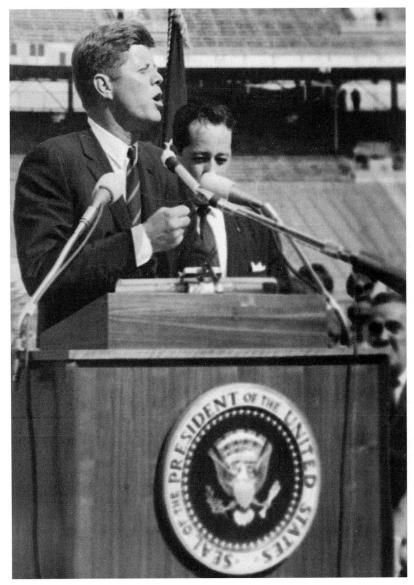

President Kennedy addresses
the crowd at the Orange Bowl.

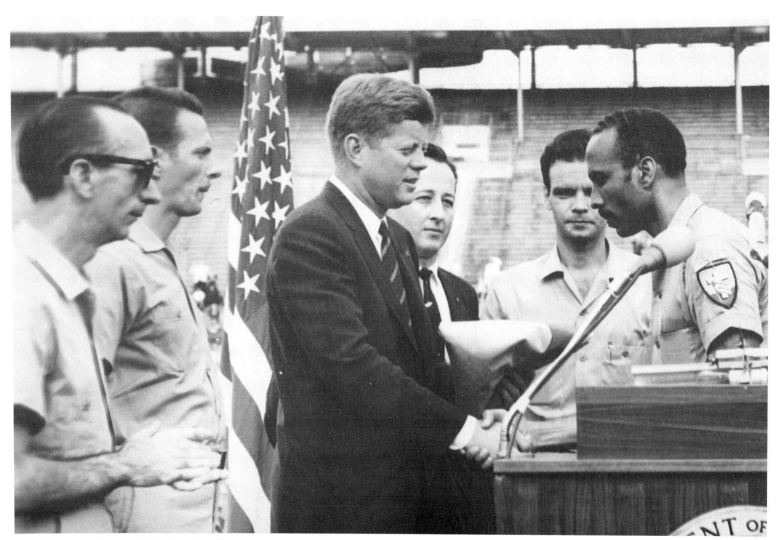

President Kennedy presents the American flag to one
of the heroes of the Bay of Pigs invasion.

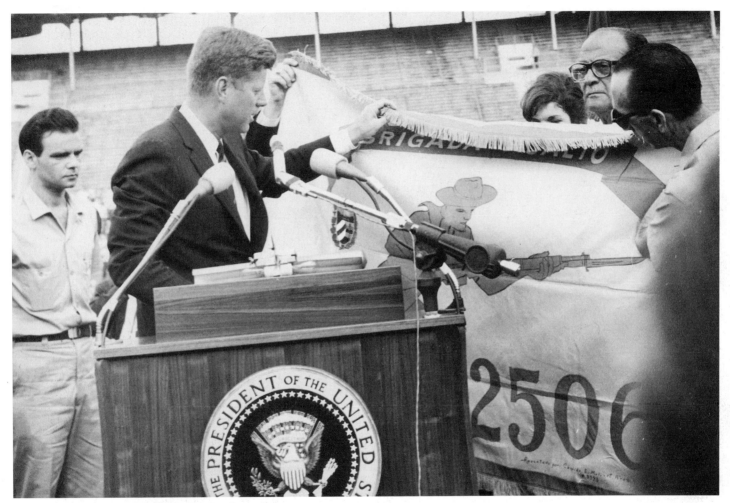

President Kennedy accepts the Brigade 2506 flag and
promises that it will soon be raised "in a free Havana."
The flag is housed at the U.S. State Department's
Office of Cuban Affairs.

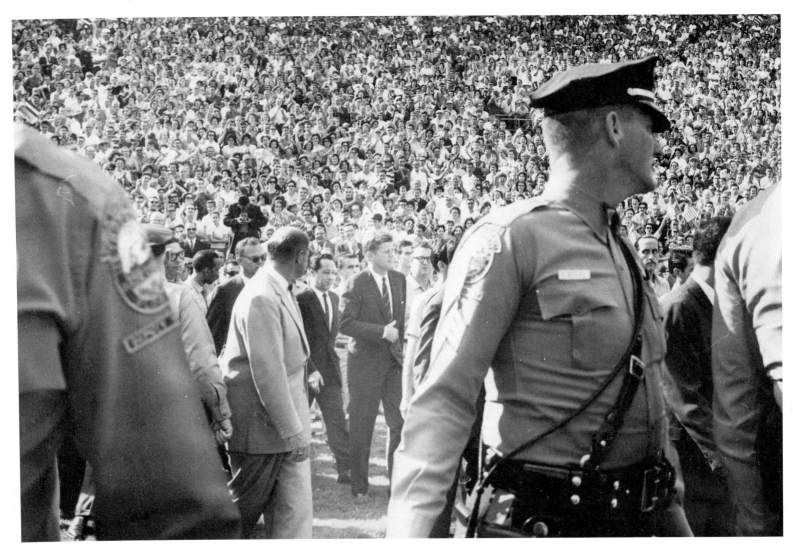

President Kennedy and other officials exit the Orange Bowl
after the homecoming celebration.

Notes

1. Leycester Coltman, *The Real Fidel Castro* (New Haven and London: Yale University Press, 2003), 24.
2. Hugh Thomas, *Cuba: The Pursuit of Freedom* (New York: Harper and Row, 1971), 811, 812, 819; Jaime Suchlicki, *Cuba: From Columbus to Castro* (New York: Charles Scribner's Sons, 1974), 144.
3. Mario Llerena, *The Unsuspected Revolution: The Birth and Rise of Castroism* (Ithaca and London: Cornell University Press, 1978), 202–4; Mario Lazo, *Dagger in the Heart: American Policy Failures in Cuba* (New York: Twin Circle, 1968), 141–49; Thomas, *Cuba: Pursuit of Freedom,* 815.
4. Lazo, *Dagger in the Heart,* 88–89.
5. Juan Clark, *Cuba: mito y realidad* (Miami and Caracas: Saeta Ediciones, 1992), 33.
6. Georgie Anne Geyer, *Guerrilla Prince: The Untold Story of Fidel Castro* (Boston, Toronto, and London: Little, Brown and Co., 1991), 128; Wyatt MacGaffey and Clifford Barnett, *Cuba: Its People, Its Society, Its Culture* (Westport, Conn.: Greenwood Press, 1962), 232.
7. Thomas, *Cuba: Pursuit of Freedom,* 867.
8. Suchlicki, *Cuba: From Columbus to Castro,* 167, 168.
9. MacGaffey and Barnett, *Cuba: Its People,* 240.
10. Thomas, *Cuba: Pursuit of Freedom,* 881.
11. Ibid., 896–901.
12. Ibid., 909–10.
13. Ibid., 919–20.
14. Lazo, *Dagger in the Heart,* 124, 125.
15. Geyer, *Guerrilla Prince,* 168, 169.
16. Lazo, *Dagger in the Heart,* 126, citing Matthews's February 24, 1957, article in the *New York Times.*
17. Geyer, *Guerrilla Prince,* 168.
18. Clark, *Cuba: mito y realidad,* 38.
19. Paul Johnson, *Modern Times: The World from the Twenties to the Eighties* (New York: Harper and Row, 1983), 621.
20. Lazo, *Dagger in the Heart,* 128, 129.
21. Johnson, *Modern Times,* 622.
22. Llerena, *Unsuspected Revolution,* 102.
23. Thomas, *Cuba: Pursuit of Freedom,* 944–45.
24. Suchlicki, *Cuba: From Columbus to Castro,* 173.
25. Ibid.

26. Thomas, *Cuba: Pursuit of Freedom*, 938–40.
27. Lowry Nelson, *Cuba: The Measure of a Revolution* (Minneapolis: University of Minnesota Press, 1972), 13.
28. Thomas, *Cuba: Pursuit of Freedom*, 951.
29. Ibid.
30. Ibid., 980.
31. Lazo, *Dagger in the Heart*, 135.
32. Ibid., 162.
33. Ibid., 163.
34. Thomas, *Cuba: Pursuit of Freedom*, 997.
35. Ibid., 1002, 1006.
36. Clark, *Cuba: mito y realidad*, 45.
37. Lazo, *Dagger in the Heart*, 168.
38. Thomas, *Cuba: Pursuit of Freedom*, 1042.
39. Ibid., 1037.
40. Johnson, *Modern Times*, 622.
41. Humberto Fontova, "Che Guevara: Assassin and Bumbler," *Mensnewsdaily.com*, 2 March 2004. Retrieved 30 September 2004. <http://www.mensnewsdaily.com/archive/f/fontova/2004/fontova030204.htm>
42. MacGaffey and Barnett, *Cuba: Its People*, 255; Thomas, *Cuba: Pursuit of Freedom*, 1082.
43. Lazo, *Dagger in the Heart*, 202–4.
44. MacGaffey and Barnett, *Cuba: Its People*, 254–57; Clark, *Cuba: mito y realidad*, 60.
45. Clark, *Cuba: mito y realidad*, 70.
46. Thomas, *Cuba: Pursuit of Freedom*, 1279.
47. Llerena, *Unsuspected Revolution*, 250.
48. Victor Triay, *Fleeing Castro: Operation Pedro Pan and the Cuban Children's Program* (Gainesville: University Press of Florida, 1998), 2–11.
49. Ibid., 12–68, 100–102.
50. Victor Triay, *Bay of Pigs: An Oral History of Brigade 2506* (Gainesville: University Press of Florida, 2001), 12–15.
51. Ibid., 13, 14, 44–46.
52. Ibid., 38–45, 68–72.
53. Ibid., 82.

All the photos in this book come from the first author's personal collection. All but a handful can be definitively attributed to Mr. José "Chilin" Trutie and were taken by Trutie during his employment as photographer for Teofilo "Tofi" Babún or for one of Babún's companies. The remainder are almost certainly Trutie's as well.

The original photos that Trutie took in Cuba are easily identified by a "Foto Trutie" stamp on the back. The photographs taken after Trutie moved to the United States in July 1960 are unstamped. To confirm that these photos are Trutie's, the first author interviewed a number of individuals who appear in the published photographs: Nino Díaz, Alejandro Bauza, Father Bez Chabebe, and Amadito Fernández, as well as Trutie's wife, "Digna."

In Cuba, Trutie would sometimes submit photos to *Carteles* or *Bohemia* magazines for credit or pay. As such, the following photos cannot be determined to have originated from Trutie's cameras:

> The photo on page 21 may or may not be Trutie's. A similar photo, taken in Santiago de Cuba, was published in *Bohemia*; in the *Bohemia* copy Castro is shown with Coronel del Río Chaviano and Comandante Morales. The caption in *Bohemia* identifies the photo as an archive photo ("Foto de Archivo").

> In 1959 *Bohemia* published a head shot of Fidel Castro in what appears to be a cropped version of the photo on page 62. The *Bohemia* photo was uncredited.

> *Bohemia* published a photo, credited to Tony Martin, that was taken on the same day and in the same location as the photo on page 54. That photo, however, is different from the one that appears in this book.

> The photo on page 66 was published in *Bohemia*. The photo is uncredited in the magazine, but the first author believes that it is Trutie's. The caption reads "UNA FIGURA QUE HONRA A CUBA." The photo on page 82 was published in *Bohemia* with the caption: "Un tribunal revolucionario dicto la sentencia de [Alejandro] García Olayón: Fusilamiento. El Capitán René Rodríguez-Veterano del M-26-7 Expedicionario del Granma, ordeno la descarga de las carabinas automáticas." The same photo has appeared in a number of other publications, including *Cuba: mito y realidad* by Juan Clark; nowhere is the photographer credited. The photograph was taken in Santiago de Cuba. Again, the first author believes that the photographer was Trutie.

The first author can confirm as an eyewitness that Trutie took a number of the photos, including the ones taken in the Orange Bowl in Miami.

The photos on pages 89 and 96, showing the *African Pilot,* were published in a number of sources and by all indications are Trutie's.

Photos on pages 14, 17, and 46 are almost certainly Trutie's, for the reasons described previously, but are not definitively identifiable as his.

Teo Babún is the author of more than one hundred manuscripts and reports on Cuban business and political issues, including *The Business Guide to Cuba*, a special report dealing with current and post-embargo business opportunities on the island; *Cuba's Sea and Air Transportation*; *Rehabilitating and Modernizing Cuba's Infrastructure*; and *The Guide to Future Privatization and Investments in Cuba*. He is a frequent guest commentator on CBS, CNN, CNBC, the BBC, and the German Television Network, and his articles have appeared in the *Miami Herald, El Nuevo Herald, The Wall Street Journal, The Economist, The Americas Business Journal*, and others.

Victor Andrés Triay is the author of *Fleeing Castro: Operation Pedro Pan and the Cuban Children's Program* (University Press of Florida, 1998) and *Bay of Pigs: An Oral History of Brigade 2506* (University Press of Florida, 2001). The latter work, which was awarded the Florida Historical Society's Samuel Proctor Oral History Award, was later released in Spanish under the title *La Patria Nos Espera* (2003). He has appeared frequently on CNN, Fox News Network, C-Span, Public Radio International, Connecticut Public Radio, and Radio Martí.

Books of Related Interest from the University Press of Florida

Afro-Cuban Voices
On Race and Identity in Contemporary Cuba
Pedro Pérez Sarduy and Jean Stubbs

Bay of Pigs
An Oral History of Brigade 2506
Victor Andrés Triay

Cuban Socialism in a New Century
Adversity, Survival, and Renewal
Edited by Max Azicri and Elsie Deal

Cuba's Foreign Relations in a Post-Soviet World
H. Michael Erisman

Cuba's Island of Dreams
Voices from the Isle of Pines and Youth
Jane McManus

Cuba's Political and Sexual Outlaw
Reinaldo Arenas
Rafael Ocasio

Cuba Today and Tomorrow
Reinventing Socialism
Max Azicri

Culture and the Cuban Revolution
Conversations in Havana
John M. Kirk and Leonardo Padura Fuentes

Fleeing Castro
Operation Pedro Pan and the Cuban Children's Program
Victor Andrés Triay

Looking at Cuba
Essays on Culture and Civil Society
Rafael Hernández, translated by Dick Cluster

Mambisas
Rebel Women in Nineteenth-Century Cuba
Teresa Prados-Torreira

Santería Healing
A Journey into the Afro-Cuban World of Divinities, Spirits, and Sorcery
Johan Wedel

For more information on these and other books, visit our website at www.upf.com.